MW00613737

ANTELO DEVEREUX, JR.

PERSPECTIVES

PHILADELPHIA

Other Schiffer Books by the Author:

Chester County Out & About	ISBN: 978-0-7643-3625-6
Maine: Out & About	ISBN: 978-0-7643-3492-4
Chester County Perspectives	ISBN: 978-0-7643-33125
Eastern Shore Perspectives	ISBN: 978-0-7643-4446-6
Maine Coast Perspectives	ISBN: 978-0-7643-3015-5

Copyright © 2015 by Antelo Devereux, Jr.

Library of Congress Control Number: 2015930739

Designed by John P. Cheek
Cover design by Molly Shields
Type set in Humanist 521 BT/Humanist 521 Lt BT

ISBN: 978-0-7643-4844-0
Printed in China

Published by Schiffer Publishing, Ltd.
4880 Lower Valley Road
Atglen, PA 19310
Phone: (610) 593-1777; Fax: (610) 593-2002
E-mail: Info@schifferbooks.com

For our complete selection of fine books on this and related subjects, please visit our website at www.schifferbooks.com. You may also write for a free catalog.

This book may be purchased from the publisher. Please try your bookstore first.

We are always looking for people to write books on new and related subjects. If you have an idea for a book, please contact us at proposals@schifferbooks.com.

Schiffer Publishing's titles are available at special discounts for bulk purchases for sales promotions or premiums. Special editions, including personalized covers, corporate imprints, and excerpts can be created in large quantities for special needs. For more information, contact the publisher.

Introduction

In 1683, Thomas Holme, the Surveyor General of Pennsylvania, created a plan for a town to be established on land strategically situated between the Delaware and Schuylkill Rivers. The land had been granted by Charles II, King of England, to William Penn, who named his "Greene Countrie Towne" Philadelphia. He also referred to it as a Holy Experiment. Accordingly, Philadelphia became the first planned city in North America.

While the Swedes were the first European settlers along the Delaware River, native Americans, the Lenni-Lenape, were the area's inhabitants at the time. Inevitably clashes occurred as the Europeans occupied more and more land. Early on William Penn, an entrepreneur who attracted English and other European settlers to farm and develop his vast land grant, agreed to a treaty with Tamanend, Chief of the Lenape in that area, for peaceful cooperation. Penn Treaty Park sits in memory of this agreement. Once part of the Lenape village of Shackamaxon, the park is adjacent to the Delaware River at 1341 N. Delaware Avenue.

Philadelphia was the center of political and commercial activity before the formation of the country and for many years afterwards. At the time of the American Revolution, it was, aside from London, the largest English-speaking city in the world. The protected position of its port on the Delaware River made naval invasion difficult, and from the earliest days the river gave the city access to the world. The fertile farmlands in the surrounding region and the availability of such resources as iron and coal provided the food and industry necessary to fuel a growing and dynamic economy well into the 19th century.

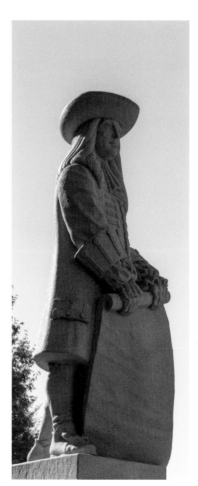

William Penn

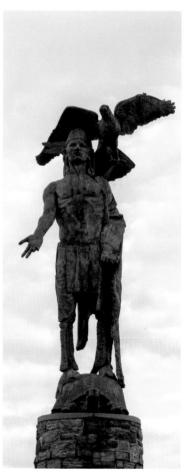

Tamanend

As the city expanded westward and outward to the suburbs, its historic area became rundown and forgotten. However, a hugely successful urban renewal project, begun in the 1950s and headed by Mayors Joseph Clark and Richardson Dilworth, together with city planner Edmund Bacon, targeted Independence Hall and neighboring Society Hill for renovation and restoration. This historic district, including Old City and Society Hill, is referred to as the most historic square mile in the country, reportedly having the largest concentration of eighteenth- and early nineteenth-century residential and history-laden architecture.

Philadelphia's commitment to conserving the historic district was the nation's first major urban renewal project and the needed spark that fired a rejuvenation of life in the city, which continues to grow today. The evidence is clear in a burgeoning resident population, proliferating high-quality restaurants, and fit people walking, running, and bicycling along the Schuylkill Trail.

I am a native of the region and have an innate fondness for Philadelphia. It's an unfairly maligned sleeper of a city. While its glory days of the eighteenth and nineteenth centuries have long passed, what remains is a rich heritage of history, cultural institutions, architecture, and many "firsts," all of which are worth bragging about.

The following photographs highlight some of the life, history, culture, and character of Philadelphia. Had space been available for twice or even three times as many pictures, they would portray a more inclusive story. The sequence of photographs follows a somewhat meandering path through the space and times of the city's core areas. It takes the reader from the seventeenth- and eighteenth-century beginnings by the Delaware River, westward to the nineteenth century expansion to the Rittenhouse Square area, outward along the Benjamin Franklin Parkway into Fairmount Park, touted as the largest landscaped park within a city in the world, and back up through South Philadelphia.

—A.D. Jr.

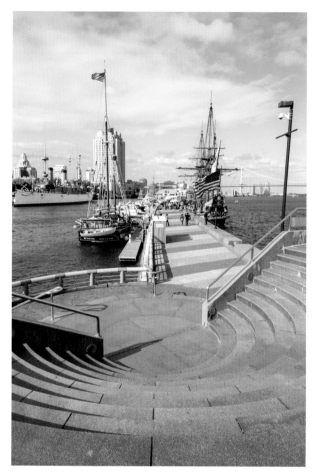

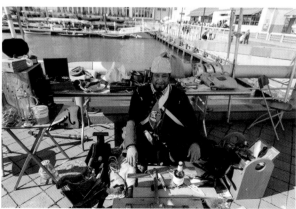

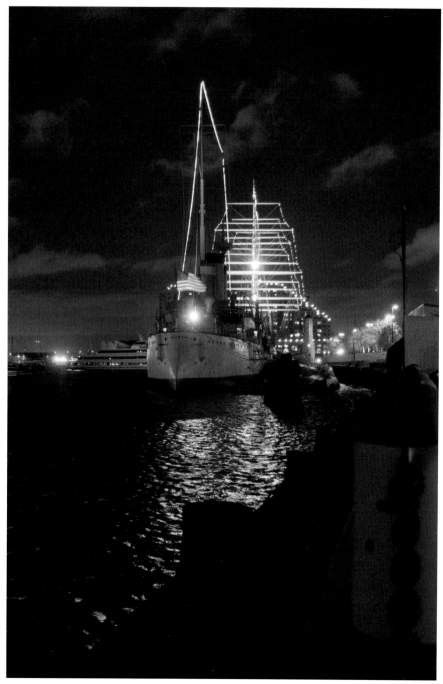

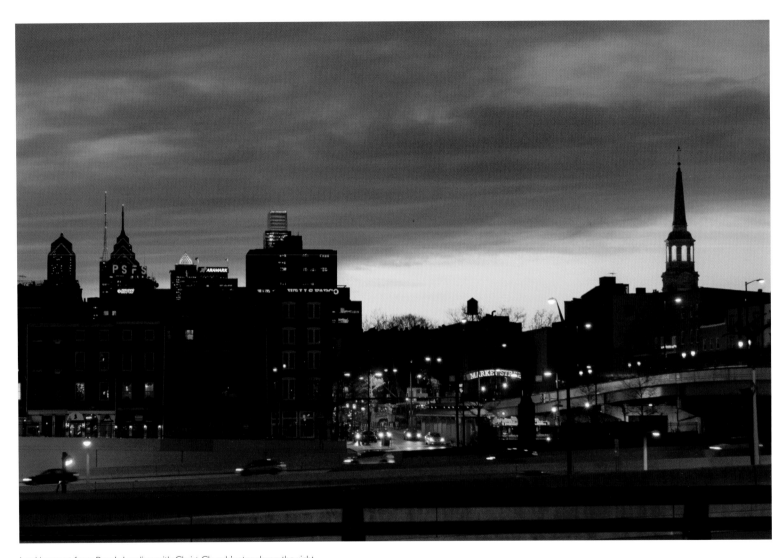

Looking west from Penn's Landing with Christ Church's steeple on the right.

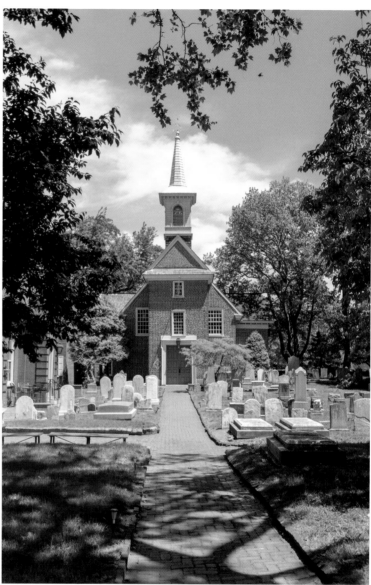

Christ Church, near 2nd and Market Streets, was established in 1695 by members of the Church of England. When the construction of this Georgian version of the church was completed in 1754, its steeple made it the tallest building in North America. The congregation included fifteen signers of the Declaration of Independence, as well as George Washington.

Gloria Dei (Old Swedes) Church, Columbus Boulevard and Christian Street, is the oldest church (1677) in Pennsylvania, having been founded by the Swedes, who were the first Europeans to settle along the Delaware River. This building was completed in 1700.

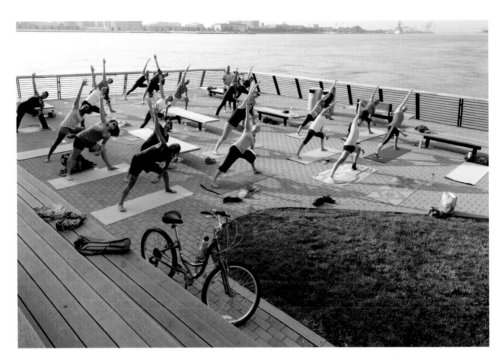

Yoga in Race Street Park on the Delaware River.

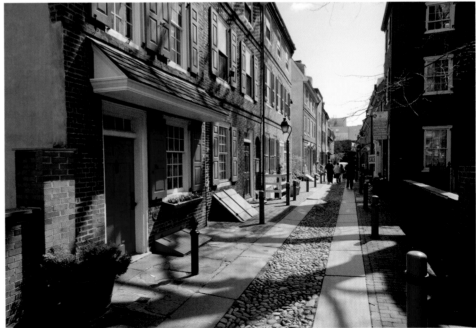

Dating back to 1702 Elfreth's Alley is considered to be the oldest residential street in the country. Various tradespeople were housed here during its early years.

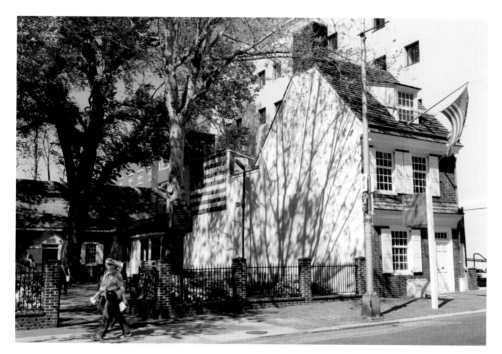

Betsy Ross House, 239 Arch Street. Whether or not the maker of the first flag of the United States lived here is a matter of dispute. Nevertheless she did live in this neighborhood of Philadelphia, so why not here?

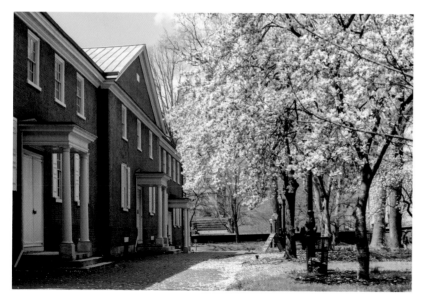

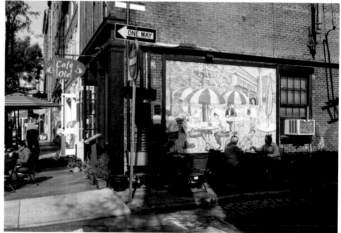

Restaurants, cafes, and art galleries abound in the Old City area.

The Arch Street Friends Meeting House, 320 Arch Street, was built on ground given to the Religious Society of Friends (Quakers) by William Penn in 1701.

Four firsts.

The First Bank of the United States, 120 S. 3rd Street, was chartered under the direction of Alexander Hamilton in 1791. The oldest bank building in the country, it was completed in 1797 and is considered to be one of the first examples of Classical monumental design.

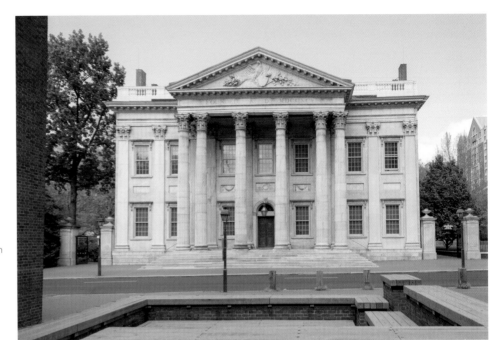

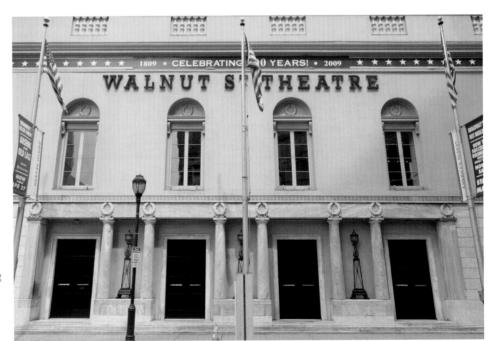

Founded in 1809 under the name of The New Circus, the Walnut Street Theatre, 825 Walnut Street, is the oldest theater in the United States and claims to be the oldest playhouse in continuous use in the English-speaking world. William Strickland was the architect.

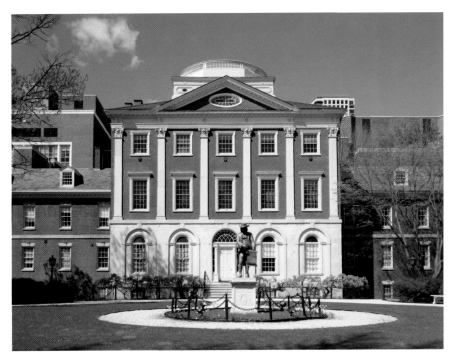

The oldest hospital in the country, Pennsylvania Hospital, viewed from 8th and Pine Streets, was founded in 1751 by Benjamin Franklin and Thomas Bond. Its building, completed in 1755, is still in use today by the hospital.

A reconstruction of Library Hall sits on the site of the original building, near 5th and Chestnut Streets, that housed the Library Company of Philadelphia, which was founded by Benjamin Franklin. It served as the Library of Congress until 1800.

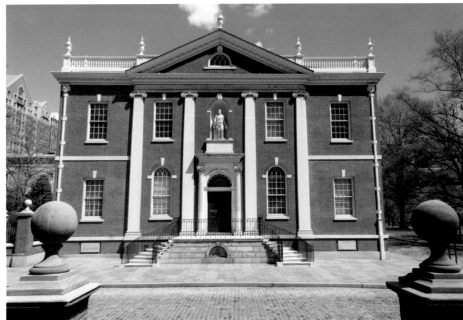

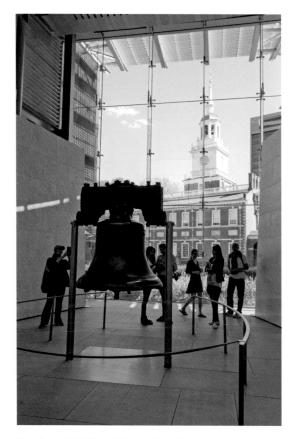

The Liberty Bell (6th and Chestnut Streets)

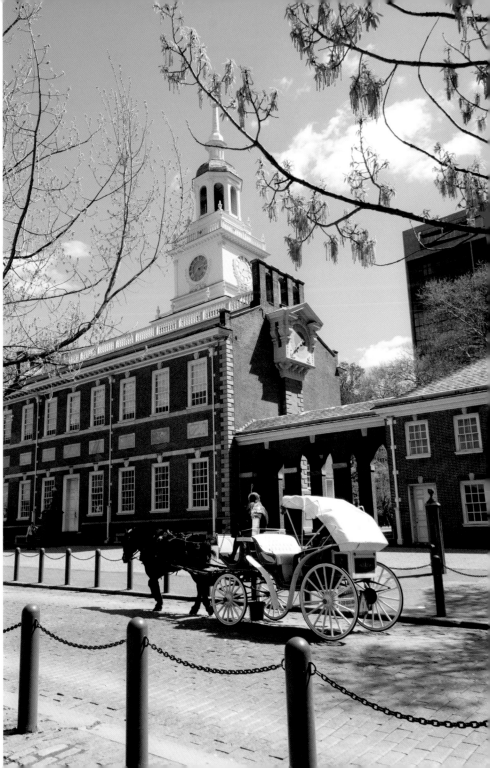

Independence Hall, 520 Chestnut Street, was completed in 1753 for the colonial legislature of the Province of Pennsylvania. Later, the Declaration of Independence and U.S. Constitution were debated and adopted there, in 1776 and 1789, respectively.

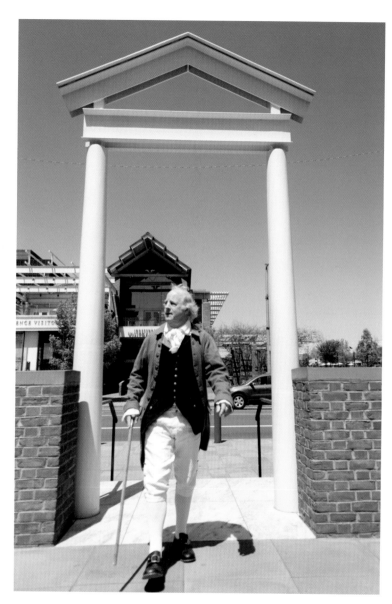

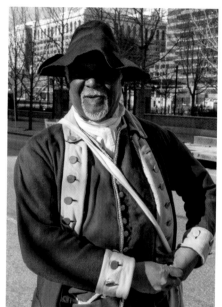

Expert re-enactors of the period greet and guide visitors around the historic area, commonly referred to as Old City.

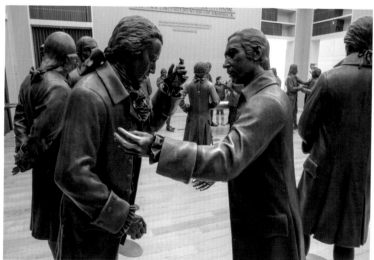

"John Adams" revisits The President's House, 6th and Market Streets, where both George Washington and he lived when Philadelphia was the capital of the nation.

One can rub elbows with the signers of the Constitution at the National Constitution Center on the north end of Independence Mall opposite Independence Hall.

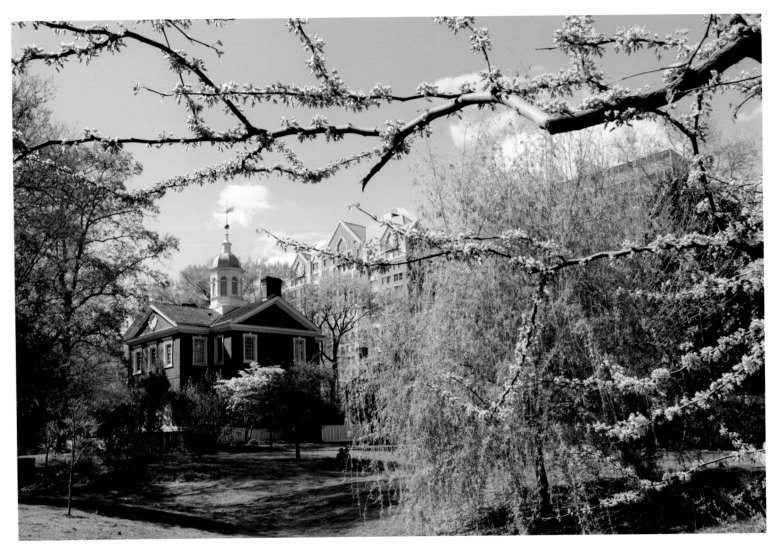

Carpenters' Hall, 320 Chestnut Street, is owned by the Carpenters' Company, the oldest existing trade guild in the country. The first Continental Congress met here in the fall of 1774.

"Hand in Hand" is the symbol of the Philadelphia Contributionship, the first fire insurance company. It was founded in 1752 at the suggestion of Benjamin Franklin and the Union Fire Company, the first volunteer fire company in North America.

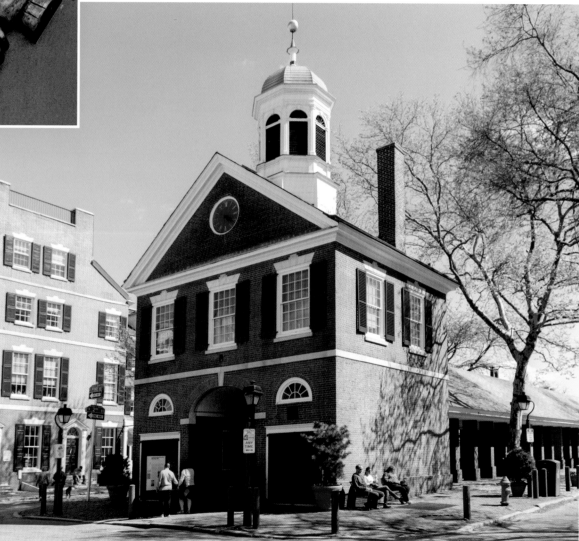

The Head House on Head House Square, 2nd and Pine Streets, was originally constructed in 1801 as a fire house. While the fire engines are long gone, the adjoining covered market area still functions.

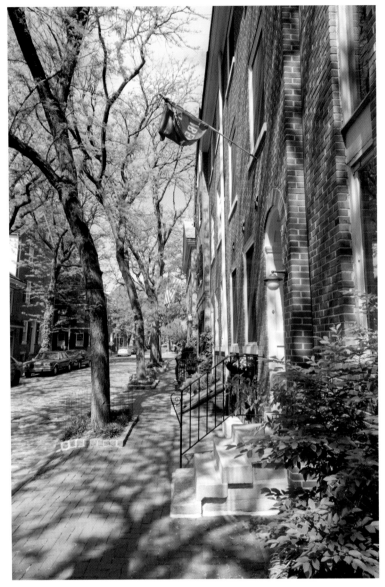

Typical eighteenth- to early nineteenth-century street in Society Hill.

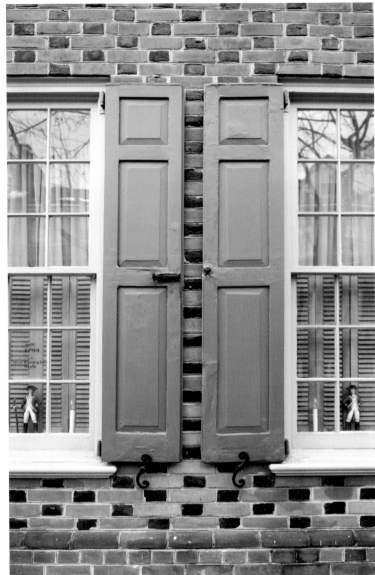

An example of Flemish Bond brickwork found on many buildings in Old City.

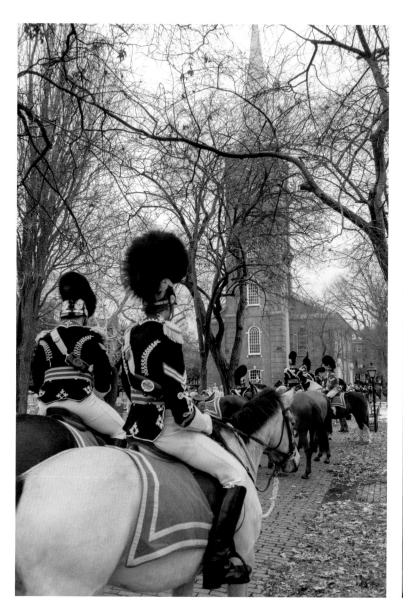

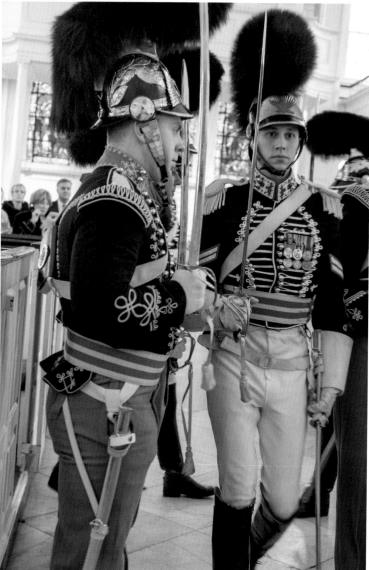

The First Troop Philadelphia City Cavalry, organized in 1774, is considered to be the oldest military unit in the country still in active service. Every year the Troop remembers George Washington's death at either Christ Church or St. Peter's Church, 3rd and Pine Streets, completed in 1791 and pictured here.

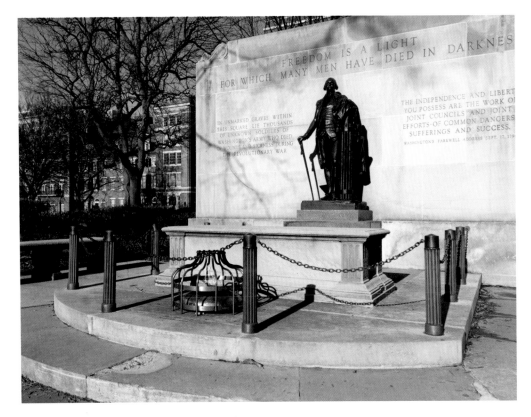

Memorial to the Unknown Revolutionary War soldier in Washington Square, 6th and Walnut Streets.

Mother Bethel African Methodist Episcopal Church, 419 S. 6th Street, was founded by the Rev. Richard Allen in 1794, and was the first independent black denomination in the United States. This building was completed in 1890.

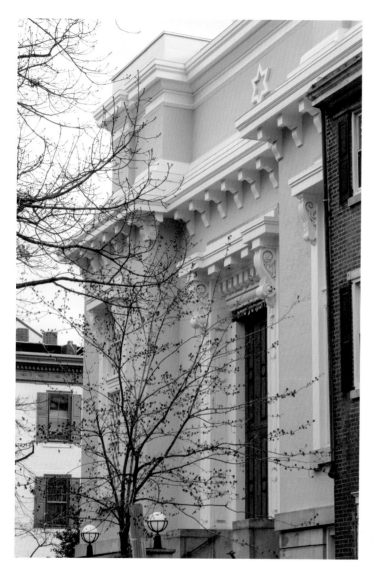

Society Hill Synagogue, 418 Spruce Street, was formerly a Baptist church.

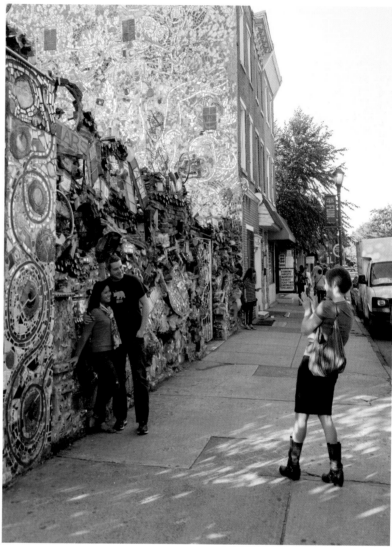

Philadelphia's Magic Gardens, at 1020 South Street, was created by award-winning mosaic mural artist Isaiah Zagar. It is well worth a visit.

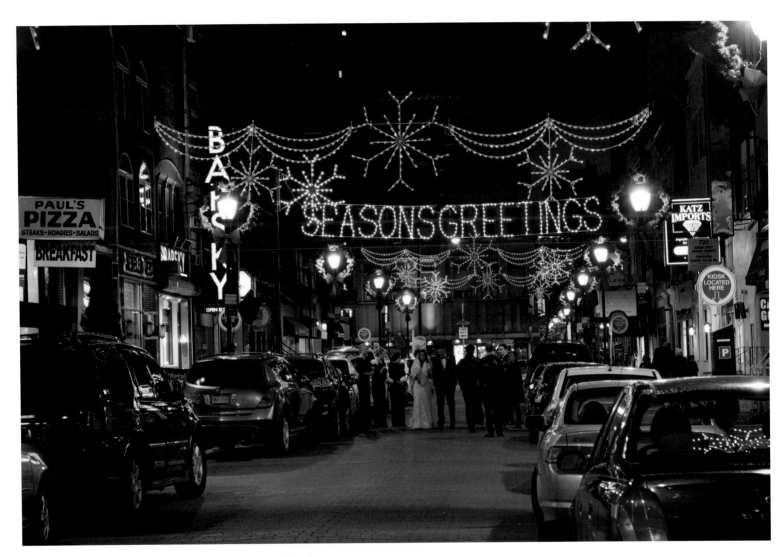

Jewelers' Row, 700 Ionic Street, is the site of the first row houses in the city.

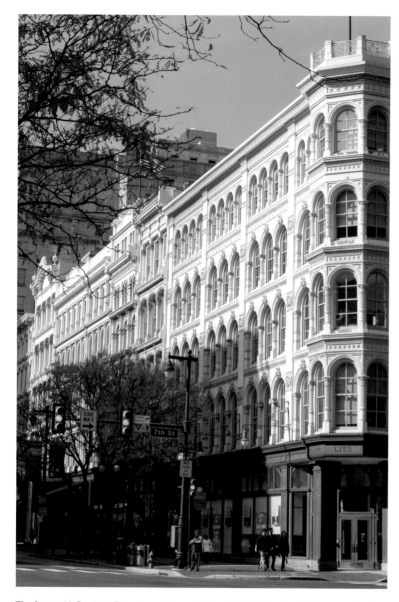

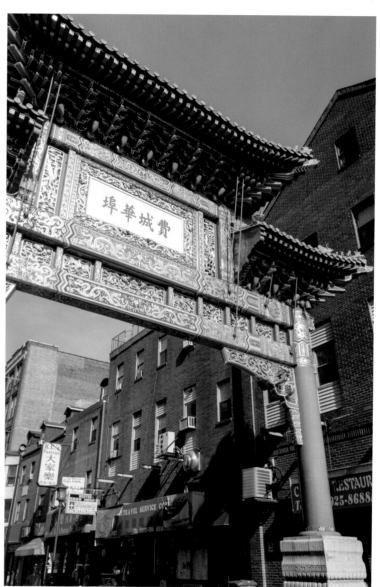

The former Lit Brothers Department store, at 7th and Market Streets, is a fine example of a cast iron façade.

Ceremonial entrance to Chinatown, 10th and Race Streets.

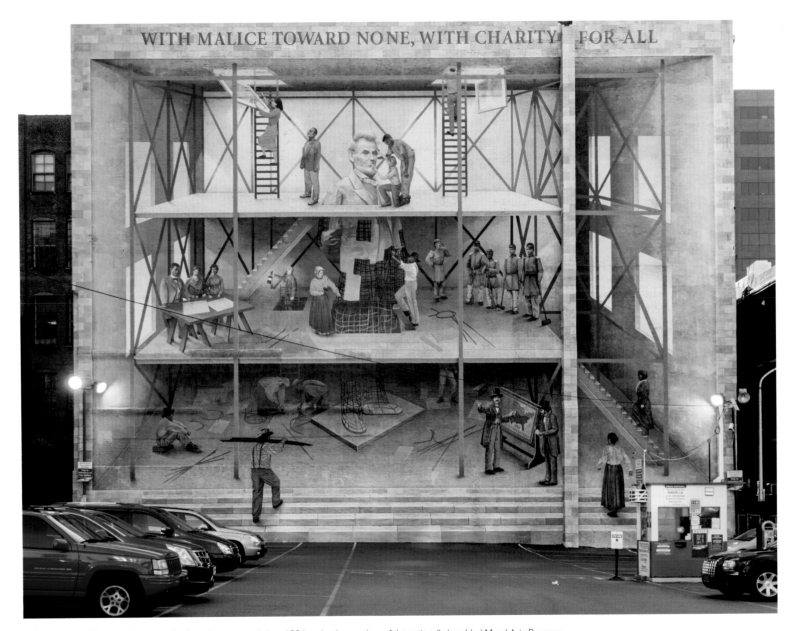

One of over 3,600 murals in the city that have been created since 1984 under the auspices of the nationally heralded Mural Arts Program.

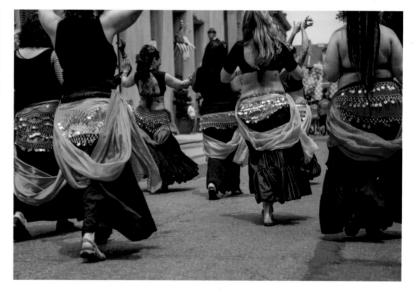

The LGBT community celebrates.

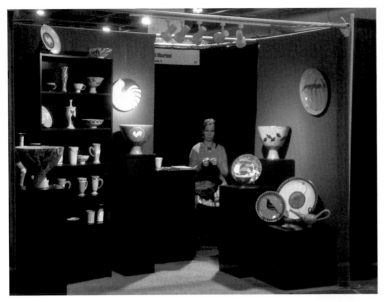

The highly prestigious Philadelphia Craft Show, offered annually by the Philadelphia Museum of Art, is the first of its kind in the country.

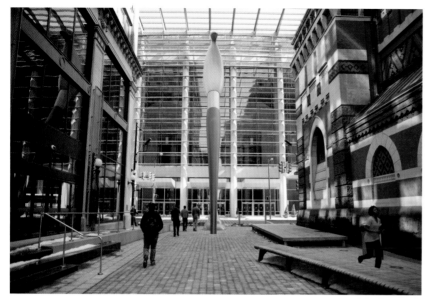

Lenfest Plaza adjacent to the Pennsylvania Academy of Fine Arts, looking toward the Pennsylvania Convention Center.

Pennsylvania Convention Center's Reading Railroad train shed.

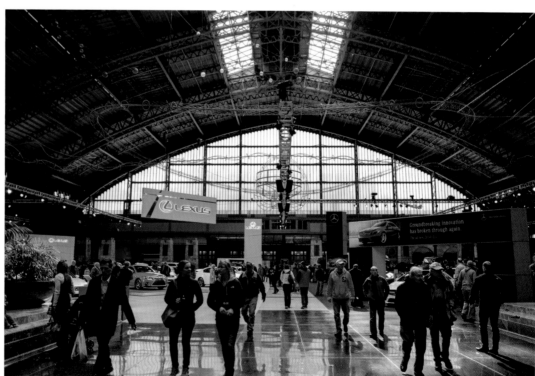

Pennsylvania Horticultural Society, founded in 1827, considers the Philadelphia Flower Show to be the largest indoor flower show in the world. The nation's first flower show was here in 1829 and featured native and exotic plants.

Talula's Garden, 210 W. Washington Square, is one of the many high quality restaurants throughout the city.

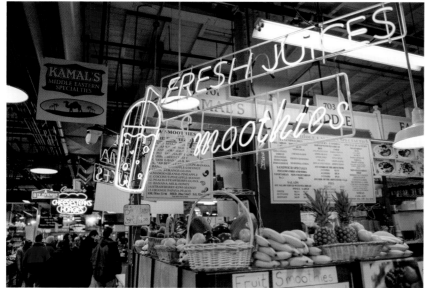

The Reading Terminal Market, 12th and Arch Streets, has been here ever since the construction of the magnificent arched train shed for the Reading Railroad. Often food, such as oysters, tasty cuts of beef, fresh produce or fancy pastries, was sent from here by train to feed a fancy party in the suburbs.

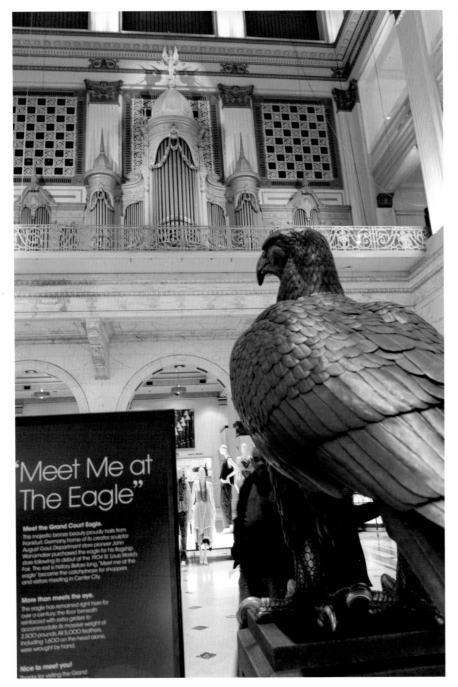

"Meet Me at The Eagle"

Meet the Grand Court Eagle.
This majestic bronze beauty proudly hails from Frankfurt, Germany, home of its creator, sculptor August Gaul. Department store pioneer John Wanamaker purchased the eagle for his flagship store following its debut at the 1904 St. Louis World's Fair. The rest is history. Before long, "Meet me at the eagle" became the catchphrase for shoppers and visitors meeting in Center City.

More than meets the eye.
The eagle has remained right here for over a century; the floor beneath reinforced with extra girders to accommodate its massive weight of 2,500 pounds. All 5,000 feathers, including 1,600 on the head alone, were wrought by hand.

Nice to meet you!
Thanks for visiting the Grand

Meet by the large bronze eagle at Macy's (originally Wanamaker's, 1300 Market Street) at noon and be treated to a daily concert on the Wanamaker Organ, the largest organ in the world, by one measure.

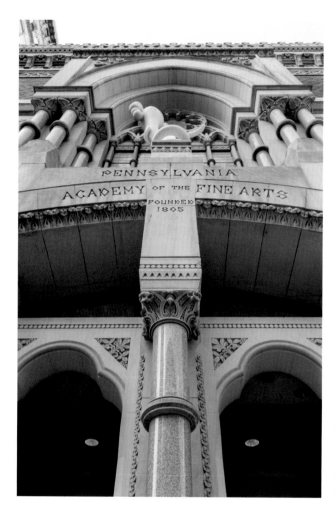

The Pennsylvania Academy of Fine Arts, Broad and Cherry Streets, founded in 1806, houses the oldest art school and museum in the country, as well as an important collection of American art.

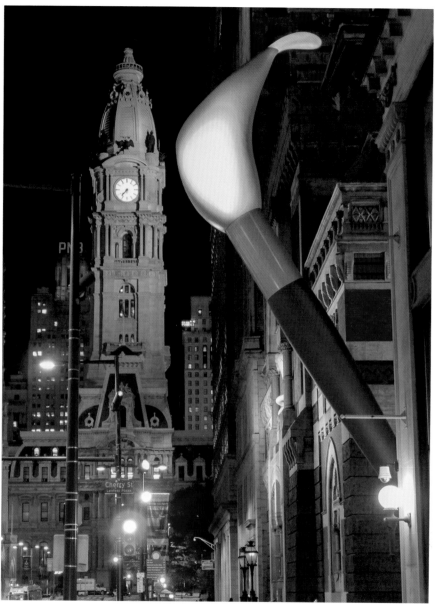

A sculpture by Claes Oldenburg outside of the Pennsylvania Academy of Fine Arts points to City Hall.

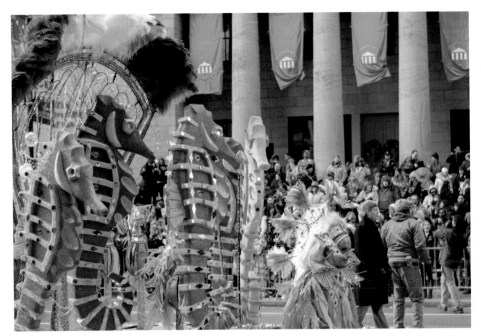

The Mummers Parade annually dresses up South Broad Street on New Year's Day. Some consider it to be the oldest folk parade in the country, with its European and African roots extending back to the seventeenth century.

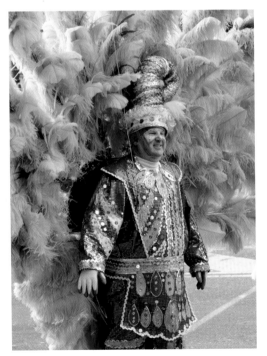

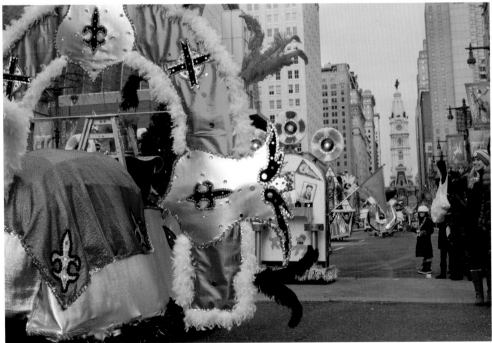

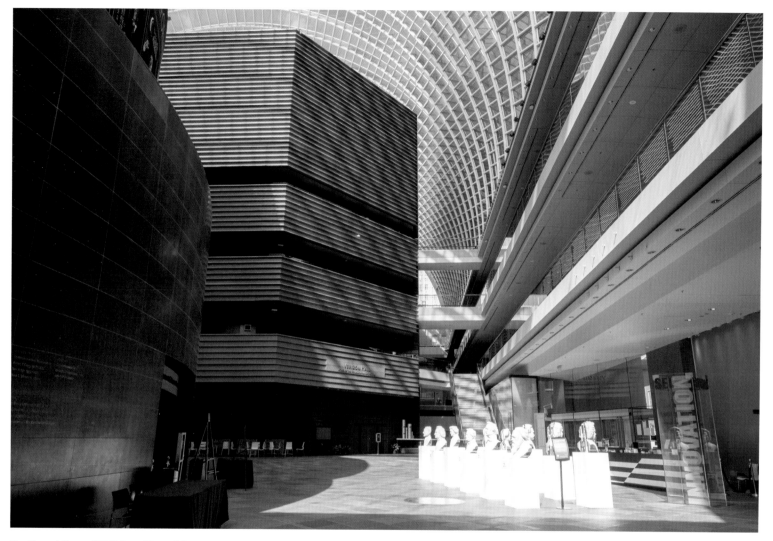

The Kimmel Center, 300 S. Broad Street, is home to Verizon Hall and the world famous Philadelphia Orchestra.

The PSFS Building, 12th and Market Streets, now the Lowes Philadelphia Hotel, was the first international-style skyscraper in the country when it was built in 1932.

Constructed about seventy years later, the Comcast Building appears to disappear into infinity and is currently the tallest in Philadelphia. Its lobby features a 2,000 square-foot, LED television screen.

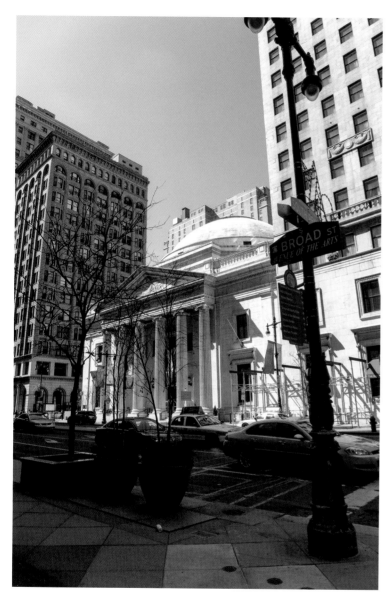

The former Girard Trust Corn Exchange Bank building, Broad and Chestnut Streets, is now home to the Ritz-Carlton Hotel.

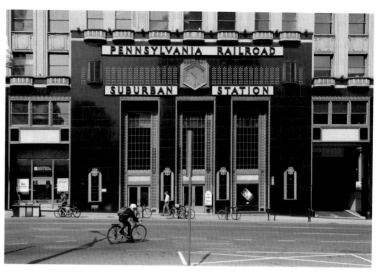

The Suburban Station building, 16th Street and JFK Boulevard, was constructed as the terminus of the Pennsylvania Railroad's commuter trains.

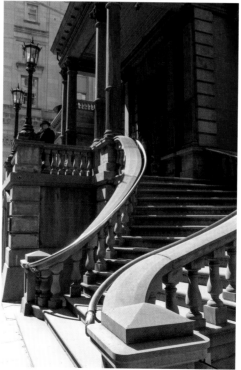

This grand staircase leads into the Union League of Philadelphia, 140 S. Broad Street.

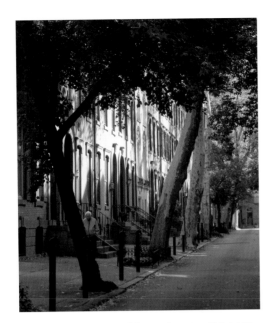

A typical residential street of nineteenth-century Philadelphia, west of Broad Street.

Rittenhouse Square, 18th & Walnut Streets, is the city's southwest quadrant square. Named after a descendant of Philadelphia's first paper maker, it was the focal point of the city's nineteenth-century expansion and residential development.

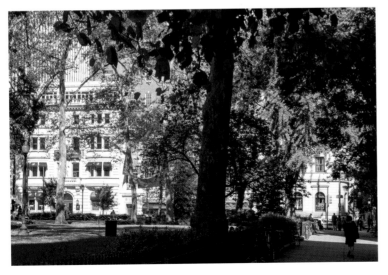

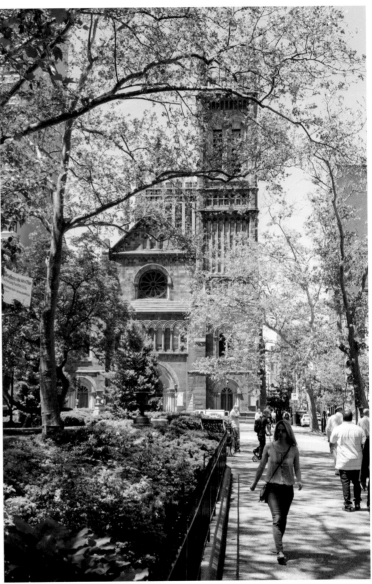

The text of "O Little Town of Bethlehem" was written by Phillips Brooks, the rector of the Church of the Holy Trinity on Rittenhouse Square. The music was composed by his organist, Louis Redner.

From the edge of Rittenhouse Square, a view of houses once occupied by prominent late nineteenth-century families.

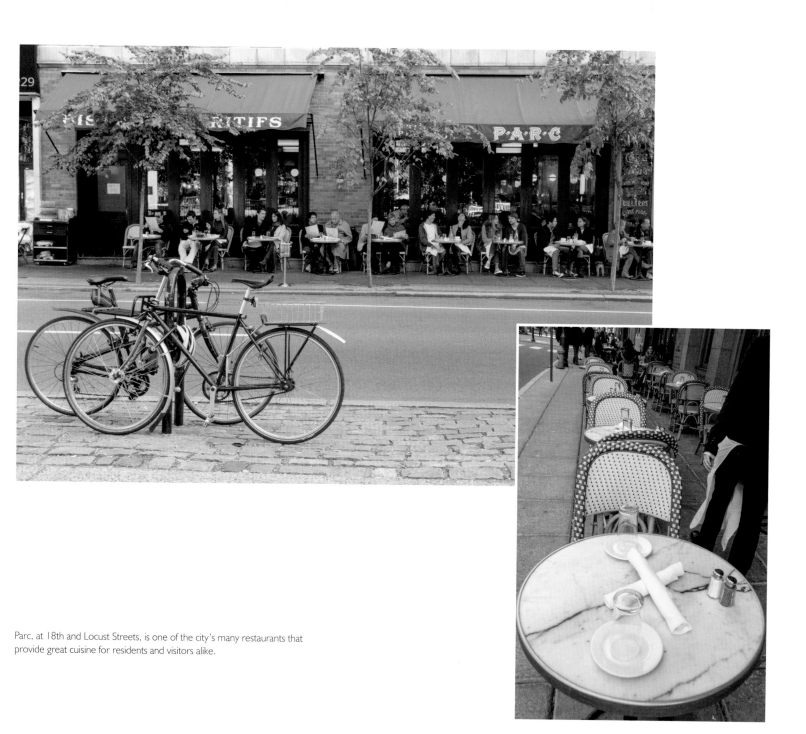

Parc, at 18th and Locust Streets, is one of the city's many restaurants that provide great cuisine for residents and visitors alike.

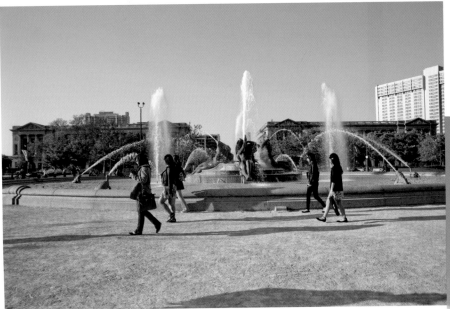

The five squares of Thomas Holme's 1683 plan for William Penn's "Greene Countrie Towne." City Hall sits on the Center Square of the original city plan. Constructed in the last quarter of the nineteenth century, it was for a short time the world's tallest structure, at 584 feet. Today it remains the world's tallest masonry structure. The statue of William Penn atop the tower was sculpted by Alexander Milne Calder. The other squares are (clockwise from top left): Logan; Franklin; Washington; Rittenhouse.

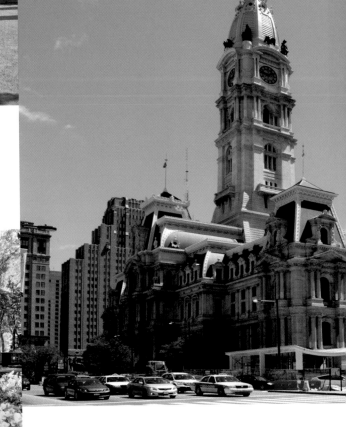

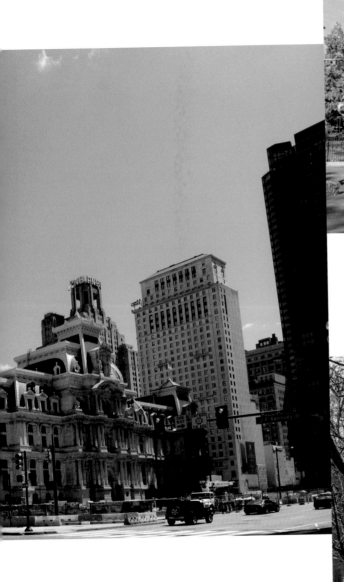

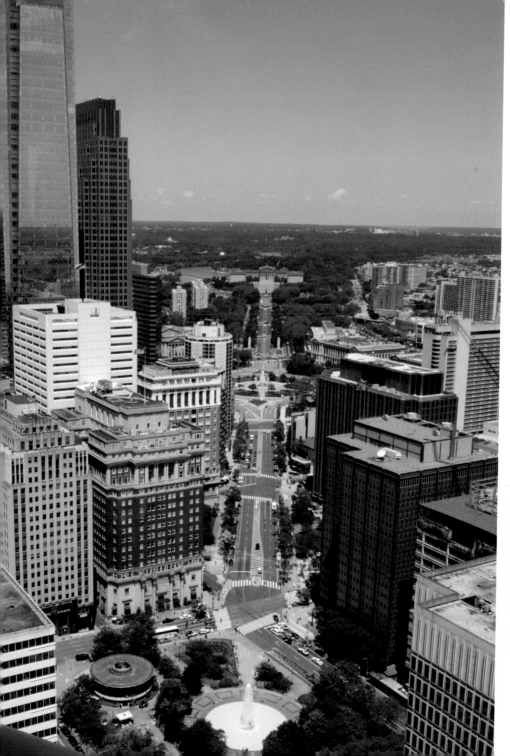

A view of Benjamin Franklin Parkway from the feet of William Penn atop City Hall. The museum-rich Benjamin Franklin Parkway was created in the second decade of the twentieth century to emulate Paris's Champs-Élysées. The original concept, to create a boulevard between city hall and the Fair Mount site of the Philadelphia Museum of Art, was the work of several architects, including Paul Philippe Cret.

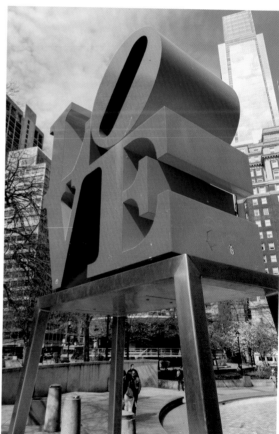

JFK Plaza, 15th Street and JFK Boulevard, is a creation of 1960s urban planning at the southeast end of Benjamin Franklin Parkway. It derives its nickname, "Love Park," from the iconic sculpture by Robert Indiana.

The annual Thanksgiving Parade, begun in 1920, is said to be the nation's first of its kind held on Thanksgiving Day and was sponsored by Gimbels, a now defunct department store.

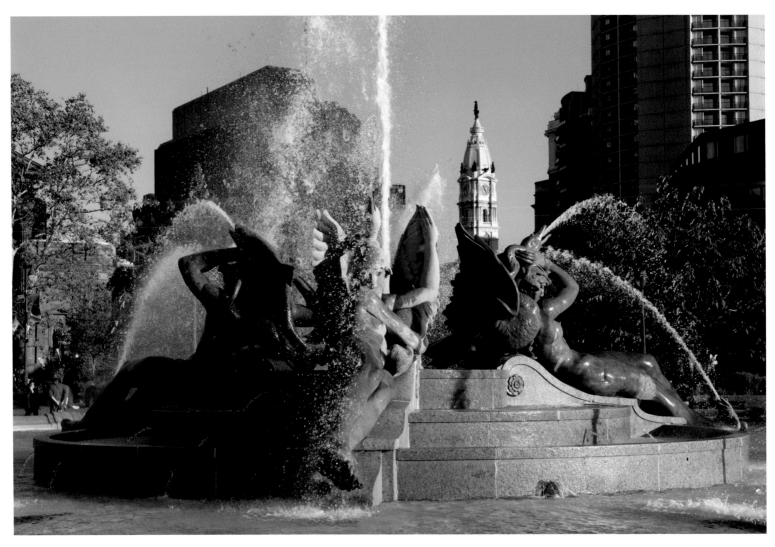

Logan Square is in the northwest quadrant of the plan for Philadelphia. Originally hangings and burials took place here. Its circular design is attributed to French landscape architect Jaques Gréber. The Swann Memorial Fountain was sculpted by Alexander Stirling Calder, father of Alexander Calder and son of Alexander Milne Calder, the sculptor of William Penn atop City Hall.

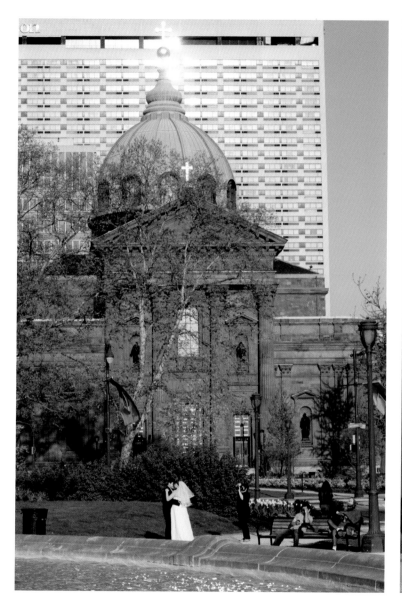
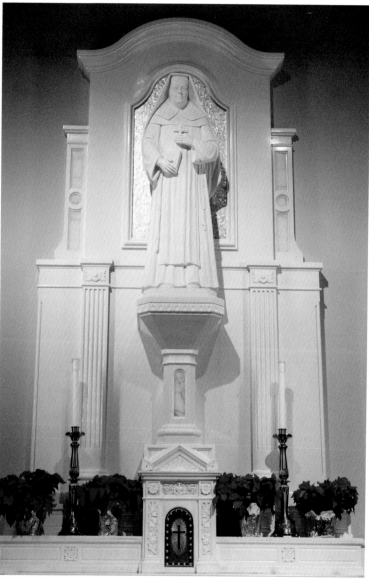

The Cathedral Basilica of Saints Peter and Paul, at Logan Square, is the mother church of the Roman Catholic Diocese of Philadelphia and is the largest Catholic Church in Pennsylvania. The basilica was completed in 1864 and houses shrines dedicated to St. John Neumann and native Philadelphian, St. Katherine Drexel, SBS.

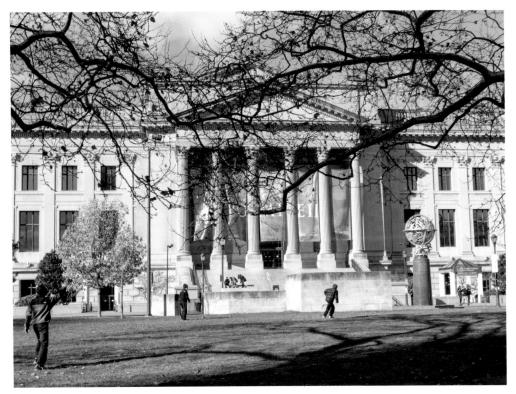

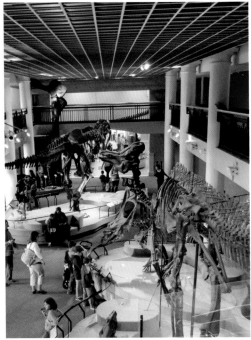

The Franklin Institute, Logan Square, the city's science museum, was founded in 1825 and moved to its current location in 1934.

The Academy of Natural Sciences of Drexel University, 1900 Benjamin Franklin Boulevard, was established in 1812 and is still active as the oldest natural science research facility and museum in the world. A substantial collection of specimens underpins a fascinating museum.

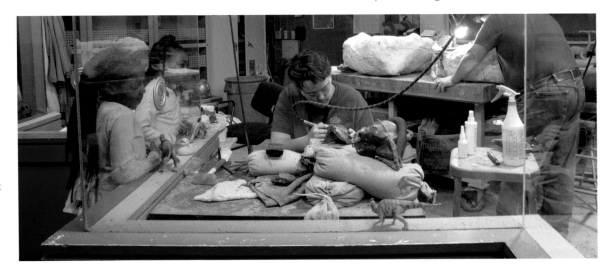

Uncovering dinosaur bones that haven't seen the light of day for at least 65 million years.

The Barnes Foundation, 2025 Benjamin Franklin Parkway, holds one of the finest collections of primarily Post-Impressionist and early Modern paintings and has, appropriately, joined the other museums along the Parkway.

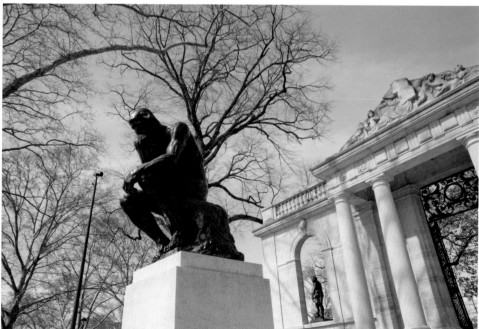

The Rodin Museum, 2154 Benjamin Franklin Parkway, contains the largest collection of Auguste Rodin's works outside of Paris.

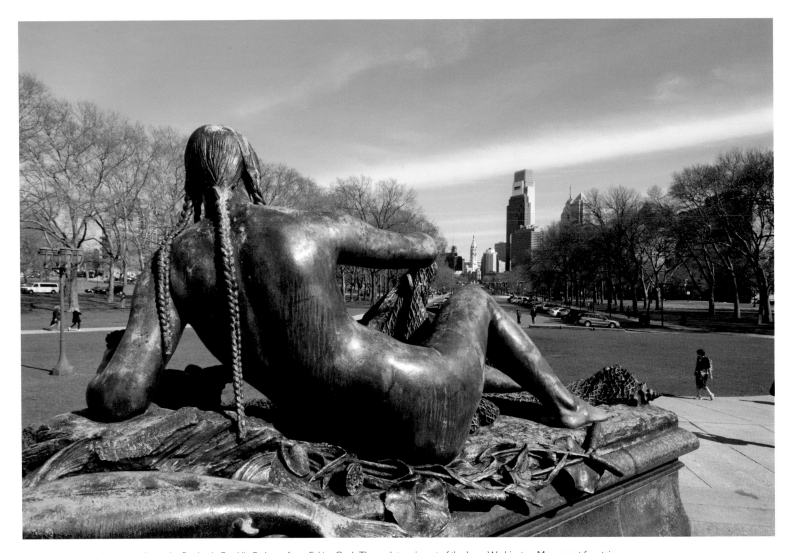

A view toward the city center down the Benjamin Franklin Parkway from Eakins Oval. The sculpture is part of the large Washington Monument fountain created by Rudolf Siemering.

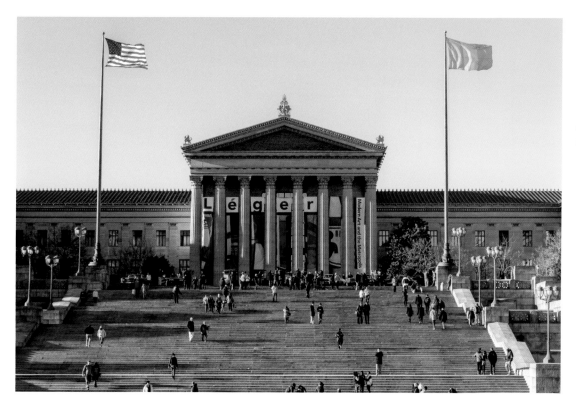

Philadelphia Museum of Art (PMA) is one of the largest art museums in the country, with a collection of over 220,000 works. The neoclassical building sits on Fair Mount at the head of Benjamin Franklin Parkway. Thanks to the movie, the east steps of the PMA are now known eponymously as the "Rocky" steps.

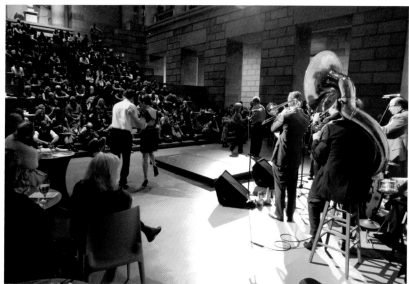

Friday evenings at the PMA feature exciting live entertainment in the grand staircase.

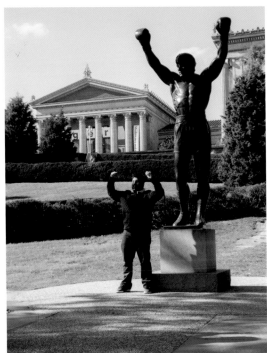

Though cast in bronze, Rocky is alive and well.

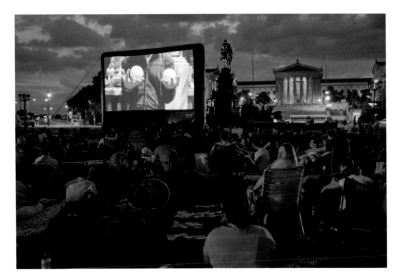

Summertime movies on Eakins Oval in front of the Philadelphia Museum of Art.

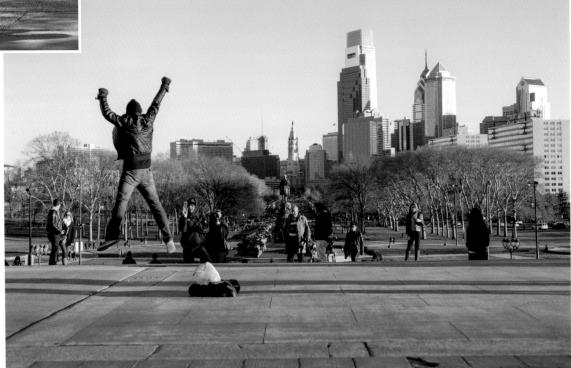

An iconic view from the PMA's plaza to city hall at the other end of the Benjamin Franklin Parkway.

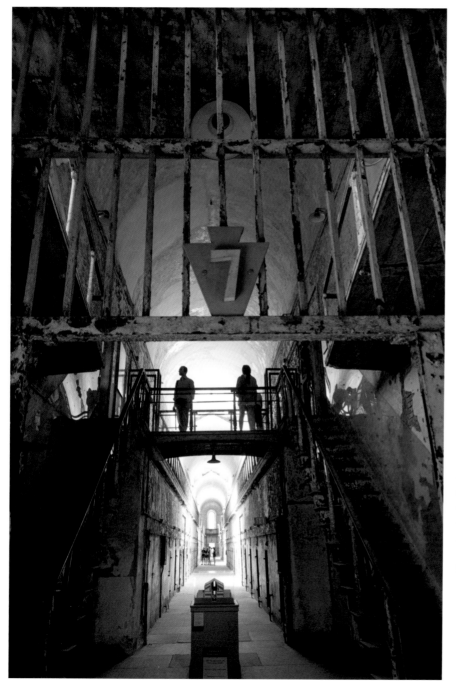

The Eastern State Penitentiary, constructed in 1829 on farmland outside the city, now 2027 Fairmount Avenue, was the enlightened manifestation of a growing concern with the conditions in American and European prisons by the members of The Philadelphia Society for Alleviating the Miseries of Public Prisons.

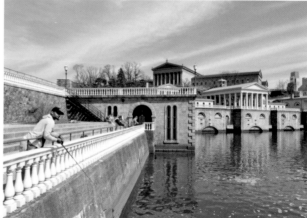

The Fairmount Waterworks were at the center of Philadelphia's second public water system. Water was pumped from the Schuylkill River up to the reservoir on Fair Mount, now the site of the Philadelphia Museum of Art, seen in the distance.

Comprising 9,200 acres, the Fairmount Park system is one of the world's largest municipal parks and the largest landscaped park in the country. The park grew outward from Lemon Hill (right of center on the hill) and for the most part was assembled in the mid-nineteenth century. It contains some of the city's cultural institutions and numerous sculptures and was the site of the 1876 Centennial Exhibition.

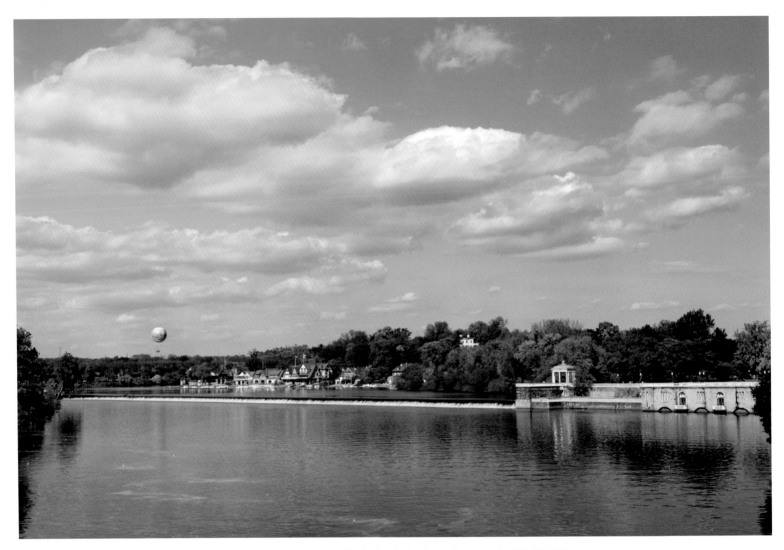

Looking up the Schuylkill River toward the Fairmount Waterworks and boathouses. The balloon in the distance floats over the Philadelphia Zoo.

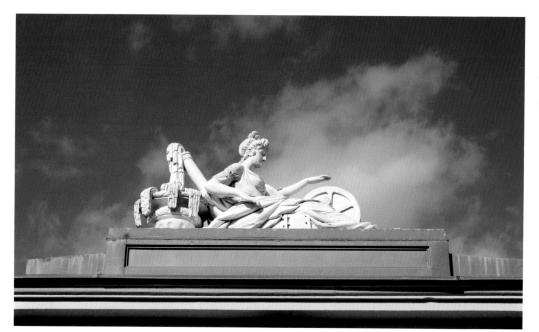

Allegorical Figure, at the Water Works, is by William Rush, one of the founders of the Pennsylvania Academy of Fine Arts.

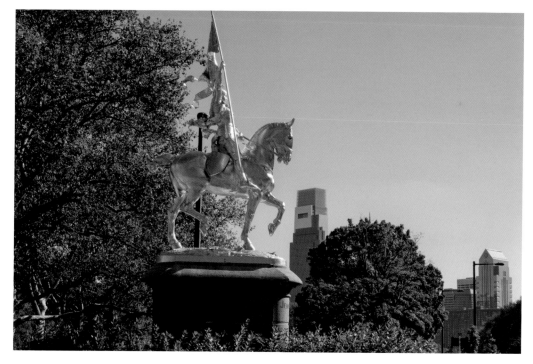

The eye-catching, gilded, triumphant statue of *Joan of Arc* stands near the entrance to the Philadelphia Museum of Art.

Baron von Steuben, one of a series of six sculptures that punctuate the western view from the Philadelphia Museum of Art.

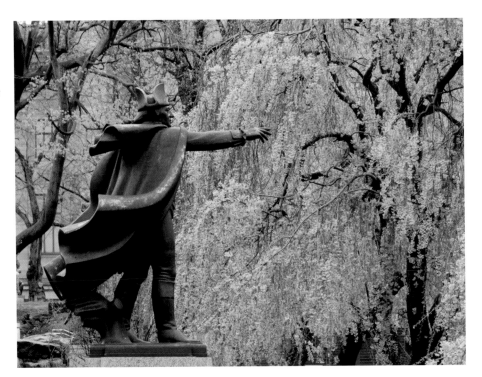

Art extends out on the west side of the museum in the form of a garden called *Lines in Four Directions in Flowers*, designed by artist Sol Lewitt.

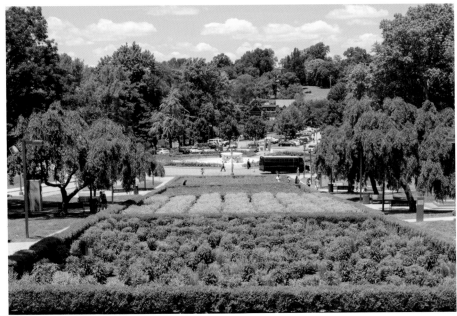

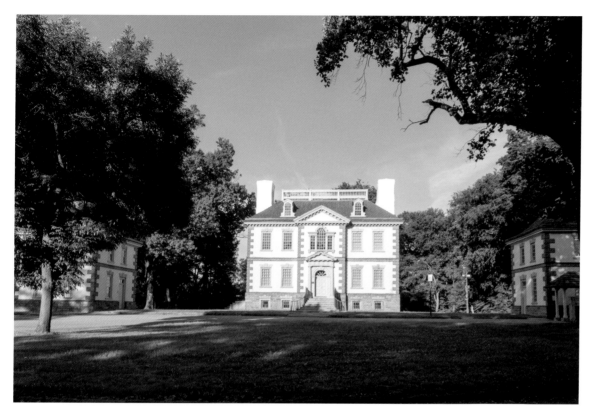

Mt. Pleasant is considered by some to be the finest Georgian house in the country and is one of eight historic country houses in Fairmount Park.

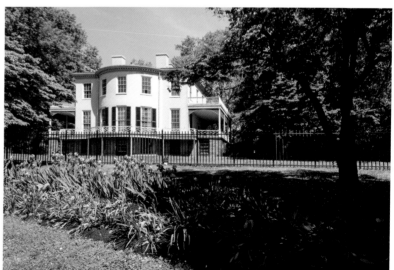

Lemon Hill—another historic house in Fairmount Park.

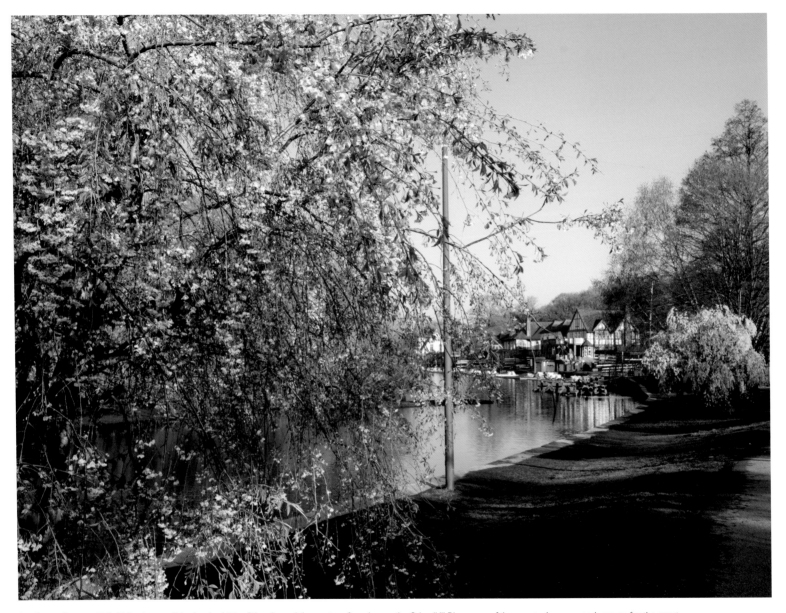

Boathouse Row on Kelly Drive is one of the iconic sights of the city and the center of rowing on the Schuylkill River, one of the country's renowned venues for the sport. The area has become a hub for walking, running, and bicycling along the Schuylkill River Trail, which parallels Kelly (East River) Drive.

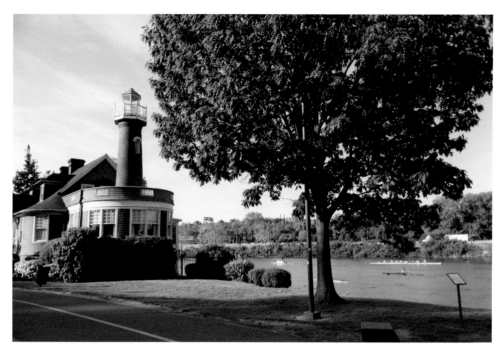

Lighthouse at the end of Boathouse Row.

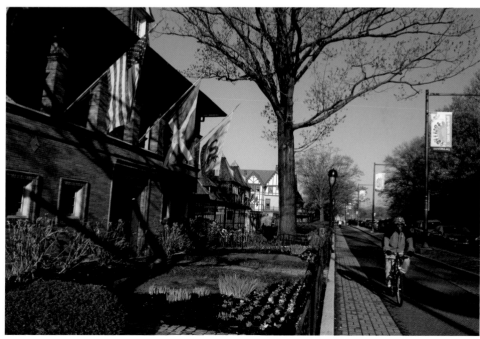

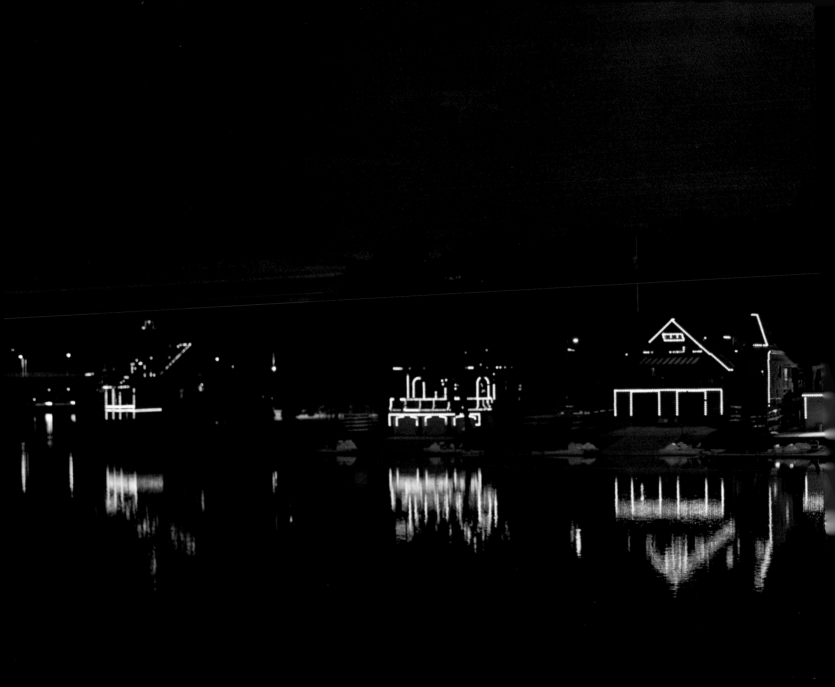

Iconic Boathouse Row illuminates the Schuylkill River. The Schuylkill Navy, founded in 1858, is the oldest athletic governing body in the country and is comprised of ten rowing clubs.

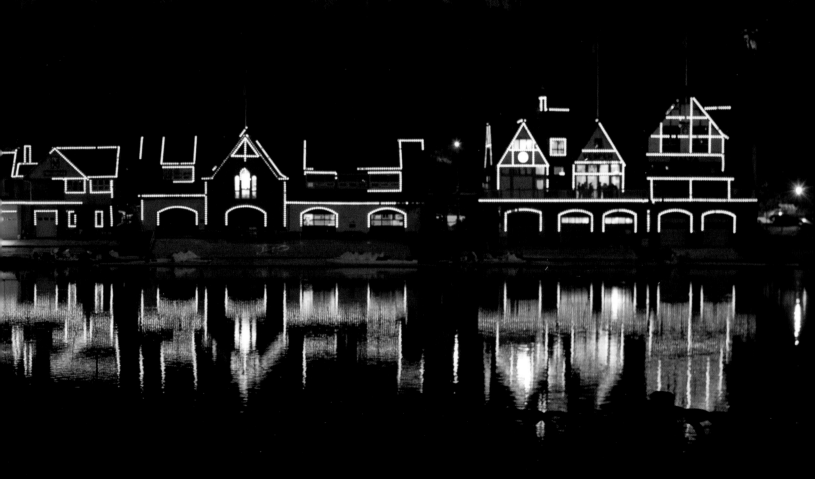

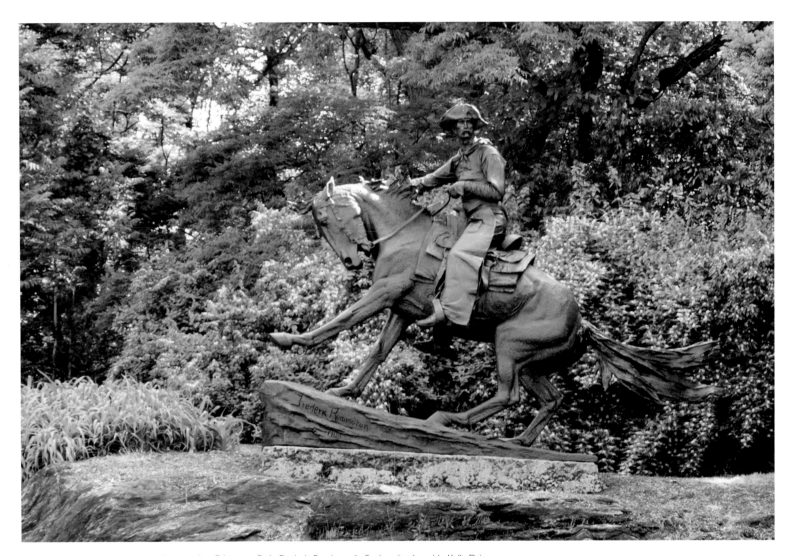

One of many wonderful sculptures that populate Fairmount Park, Frederic Remington's *Cowboy* sits alongside Kelly Drive.

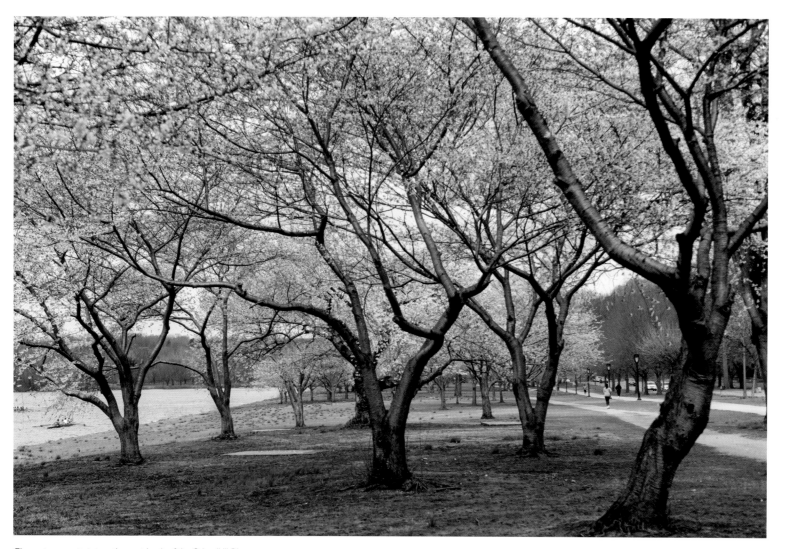

Cherry trees *au point* on the east bank of the Schuylkill River.

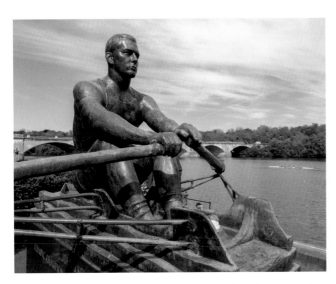

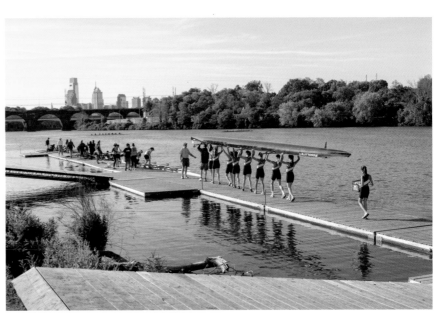

Near Boathouse Row is the statue of *John B. Kelly*, an Olympic oarsman who owned a successful brick company and was the father of Grace Kelly.

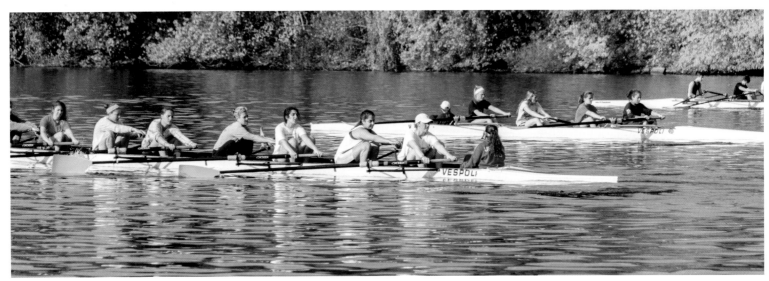

Rowing on the Schuylkill River.

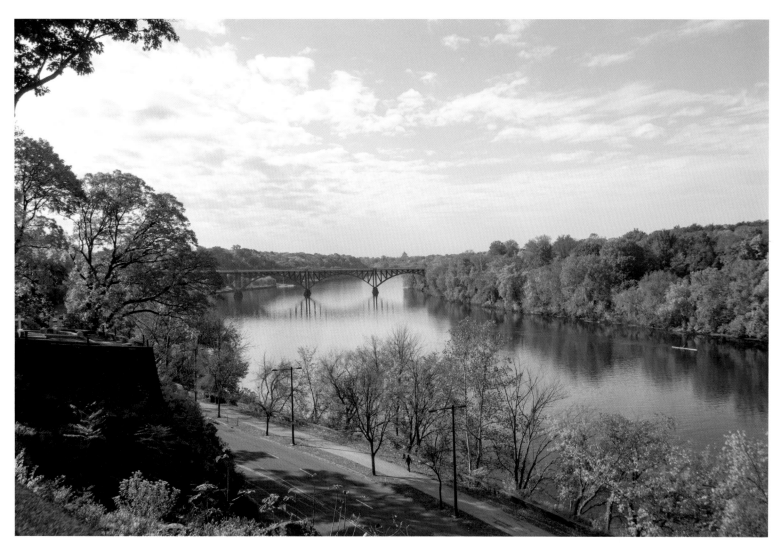

A view down Kelly Drive and the Schuylkill River from Laurel Hill Cemetery.

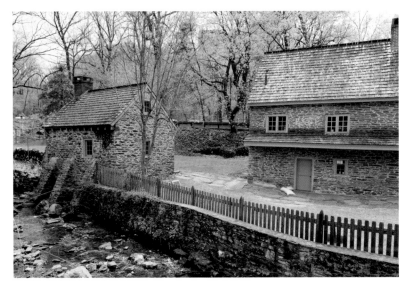

Near the Wissahickon Creek is Historic Rittenhouse Town, the site of the first paper mill in British North America built by William Rittenhouse in the early 18th century.

The valley of the Wissahickon Creek, a tributary of the Schuylkill River, is a lengthy and picturesque spine of an extension of Fairmount Park with riding and walking trails.

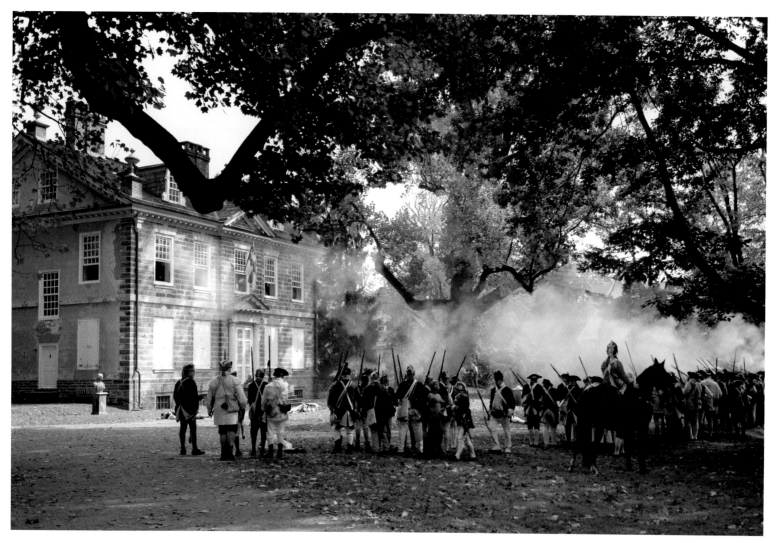

Every year the Revolutionary War's Battle of Germantown (1777) is reenacted at Cliveden. The house was given in 1972 to the National Trust by the Chew family who owned it ever since Benjamin Chew built it around 1765.

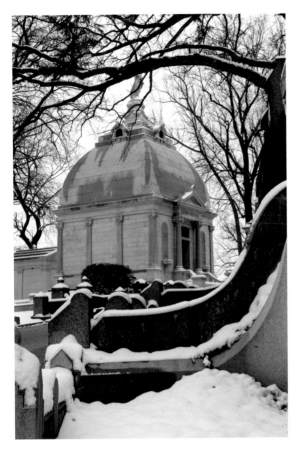

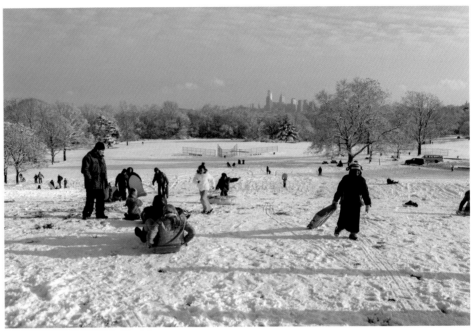

Belmont Plateau overlooks the city and at one time was considered a possible site for the United Nations.

Laurel Hill Cemetery, 3822 Ridge Avenue, overlooking the Schuylkill River, was established as a public place in 1836 in a pioneering effort to explore new landscaping and burial ideas. The resting place of many notable politicians, industrialists, and military men, it is on the National Register of Historic Places.

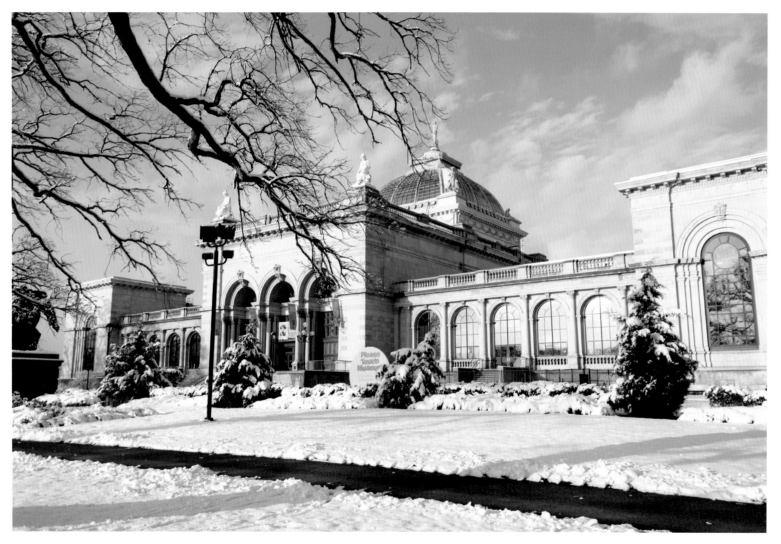

Memorial Hall in Fairmount Park was constructed for the United States Centennial in 1876 and is the only major building remaining from that world's fair. It is currently home to the Please Touch Museum for children.

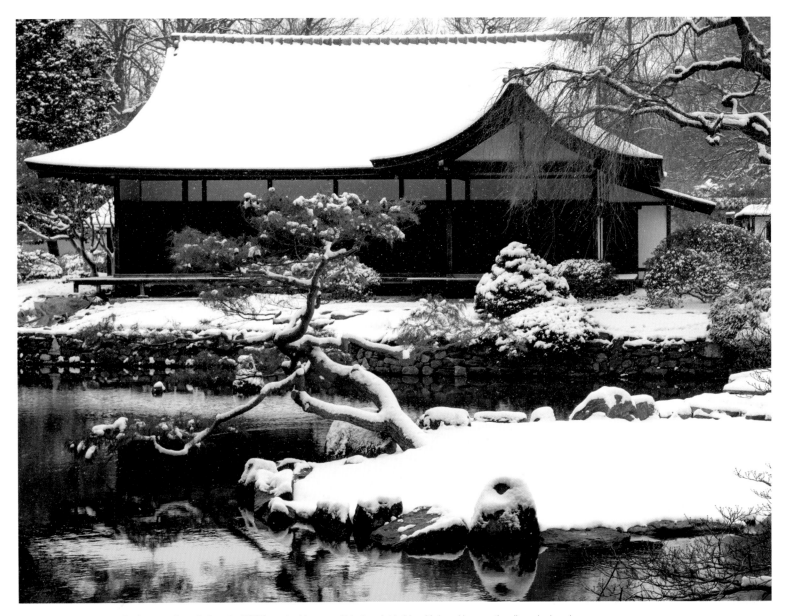

The Japanese Tea House, Shofuso, was brought here in 1958 from the Museum of Modern Art in New York and has a nationally ranked garden.

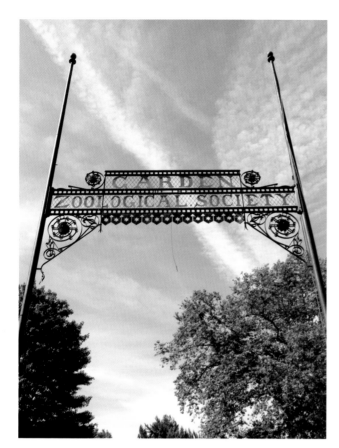

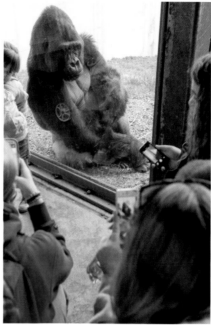

The nation's oldest zoo, the Zoological Society of Philadelphia, 3400 W. Girard Avenue, was established in 1859 and opened in 1874. The zoo has the world's first system of overhead trails for some of the animals.

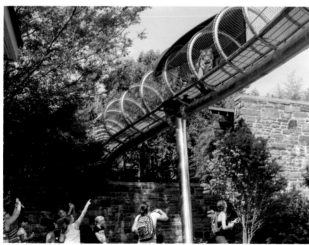

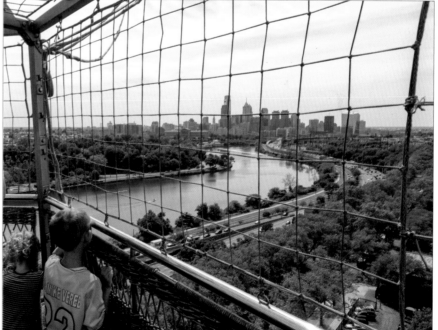

A view toward the city center from the Zoo's popular balloon.

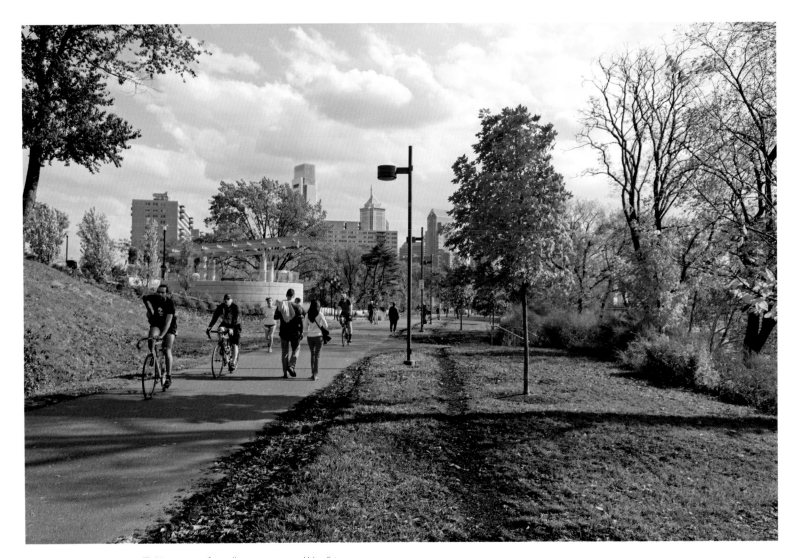

The extensive Schuylkill River Trail is a magnet for walkers, runners, and bicyclists.

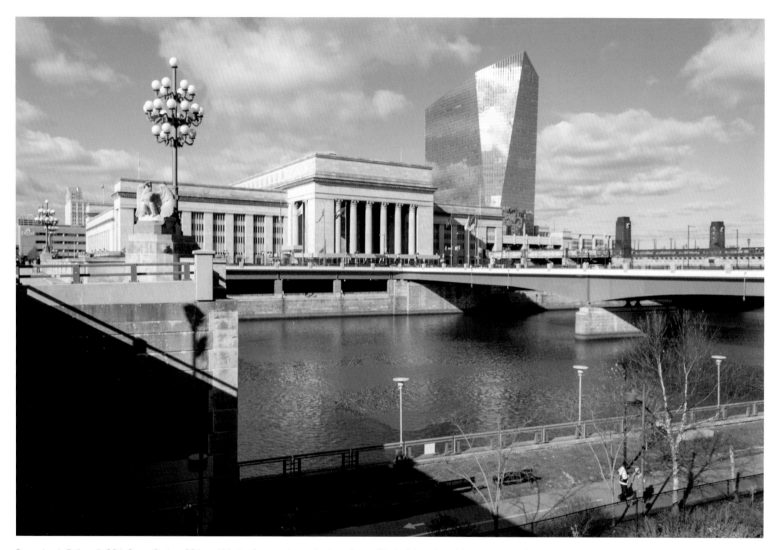

Pennsylvania Railroad's 30th Street Station, 30th and Market Streets, along with the adjacent Cira building, viewed from across the Schuylkill River. Some consider the station to be the finest along Amtrak's northeast corridor.

Drexel University, 32nd and Chestnut Streets, was founded as the Drexel Institute of Art, Science, and Technology by financier Anthony J. Drexel. His intention was to provide practical educations for men and women of all backgrounds to prepare them for productive work lives. The university lives by that mission today.

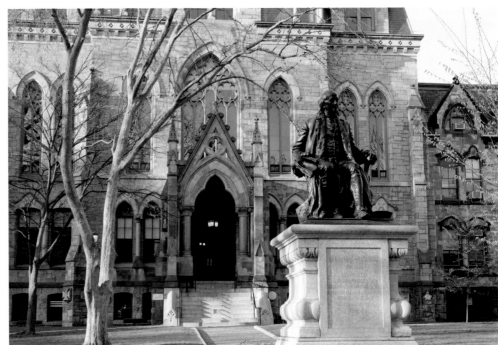

The University of Pennsylvania, 34th and Spruce Streets, considers that its beginning was a charity school established by Benjamin Franklin in 1740, from which it became one of the Ivy League universities. The world's first computer, ENIAC, was built here in 1946.

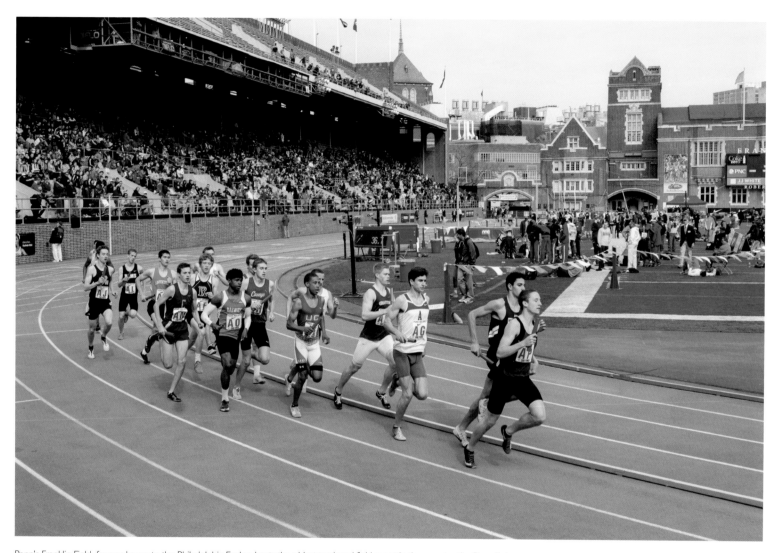

Penn's Franklin Field, former home to the Philadelphia Eagles, hosts the oldest track and field event in the country, the Penn Relays.

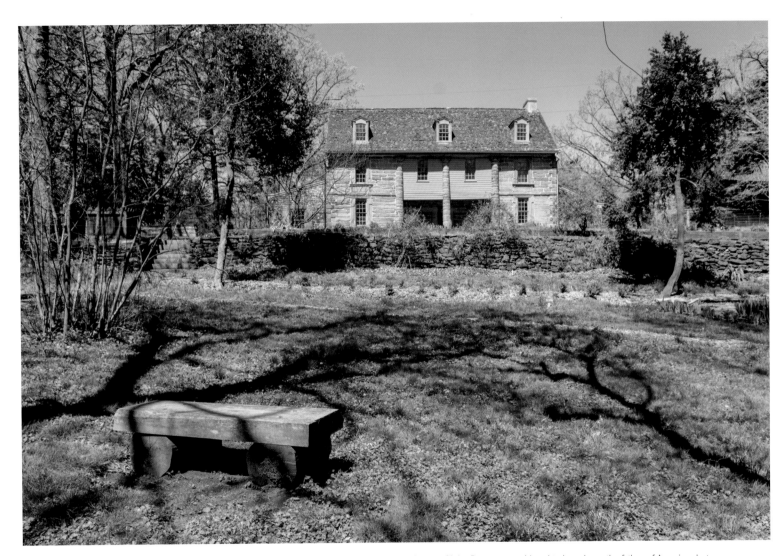

Bartram's Garden, on the Schuylkill River at 5400 Lindbergh Boulevard, was the eighteenth-century home of John Bartram, considered to have been the father of American botany. In 1765, King George III appointed him the King's Botanist for North America.

Fort Mifflin, adjacent to the airport, is one of several eighteenth-century forts built to guard the Delaware River and saw action during the American Revolution. Re-enactors of the U.S. Colored Troops recently have had an annual gathering here.

Philadelphia Navy Yard, at the confluence of the Schuylkill and Delaware Rivers in South Philadelphia, has been converted into a multi-use business park that houses various corporations, a shipbuilding company, and the U.S. Navy.

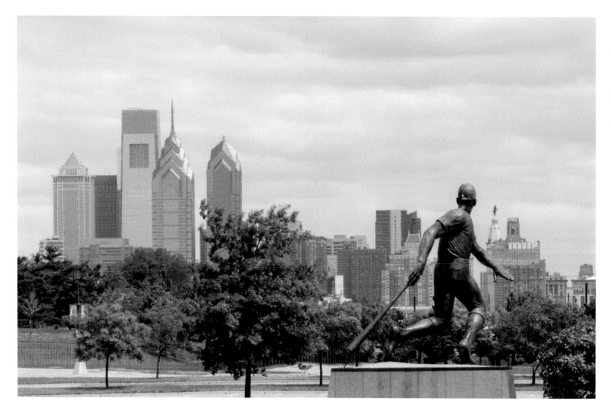

The Sports Complex in South Philadelphia houses the city's four major teams: the Eagles, the Phillies, the Flyers, and the 76ers. In addition, it has traditionally been the site of the Army-Navy football game.

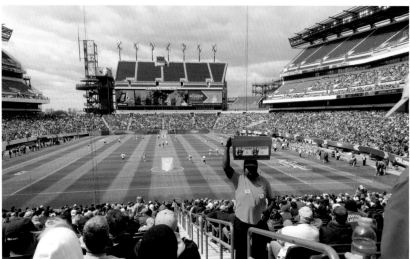

NCAA National Championship lacrosse game at Lincoln Financial Field

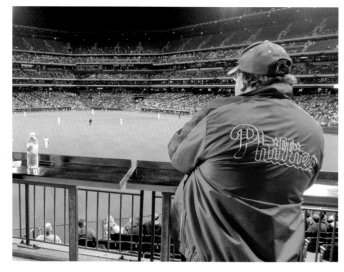

A fan looks on at Citizen's Bank Park.

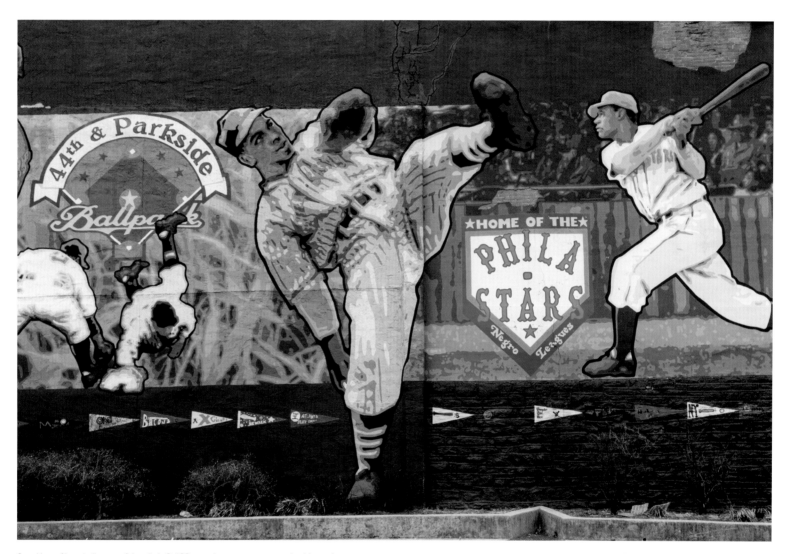

Speaking of baseball, one of the city's 3,600 murals commemorates the Negro League.

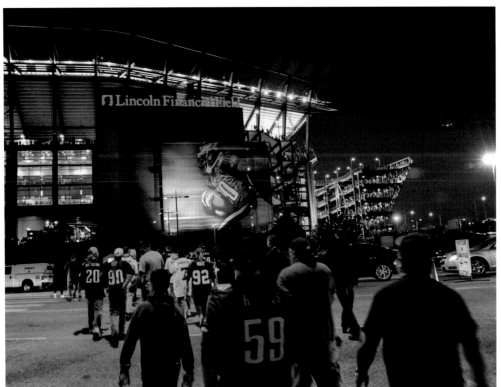

Fans rush into Lincoln Financial Field for an Eagles night game.

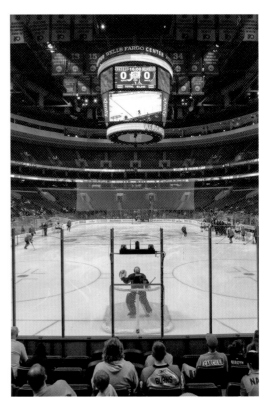

The Flyers practice in the Wells Fargo Center.

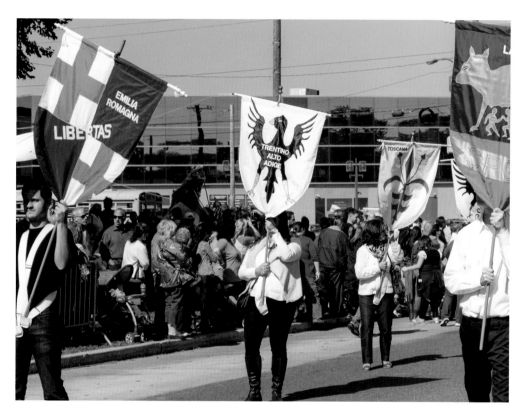

Columbus Day parade on Broad Street in South Philadelphia.

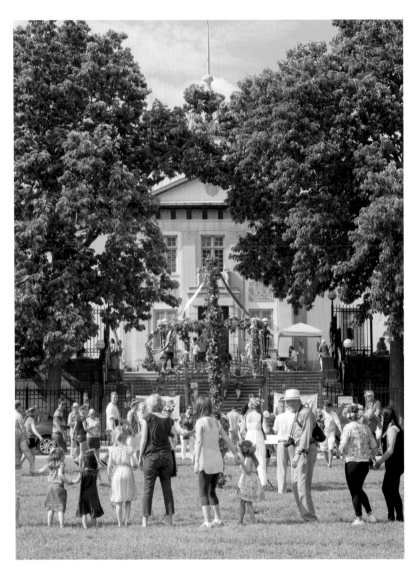

Midsommarfest at the American-Swedish Historical Museum, 1900 Pattison Avenue, reminds us that the Swedes were the first Europeans to populate the area.

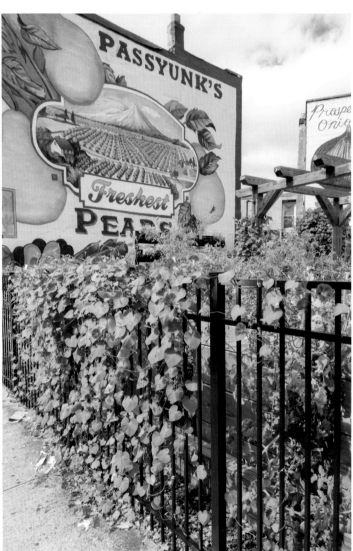

A serious urban garden in the Passyunk area of South Philly.

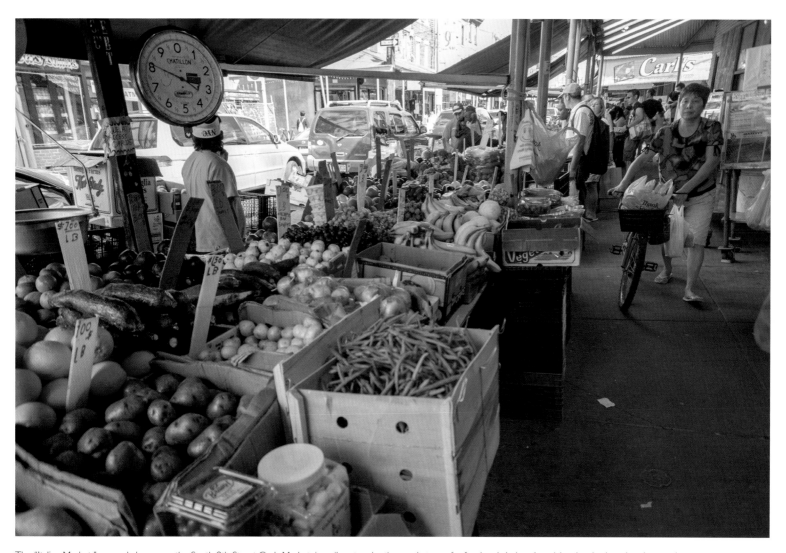

The "Italian Market," properly known as the South 9th Street Curb Market, is a vibrant and active market area for food and clothes. Its origins date back to the nineteenth century, when the South Philadelphia area was home to scores of immigrants.

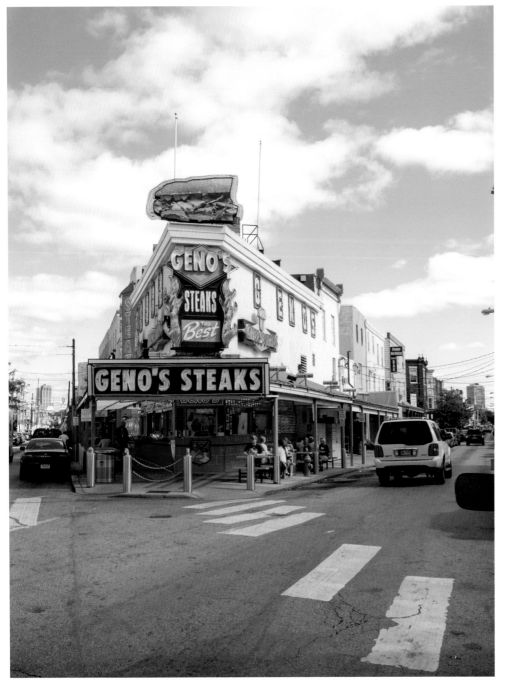

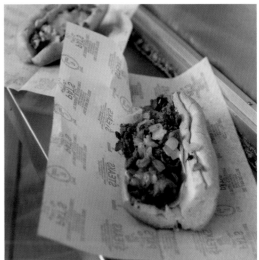

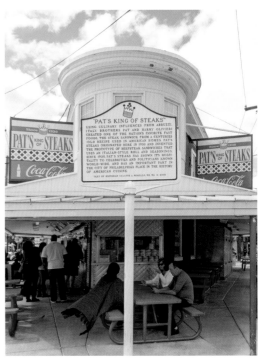

Two of many places where one can enjoy a genuine Philly cheesesteak.

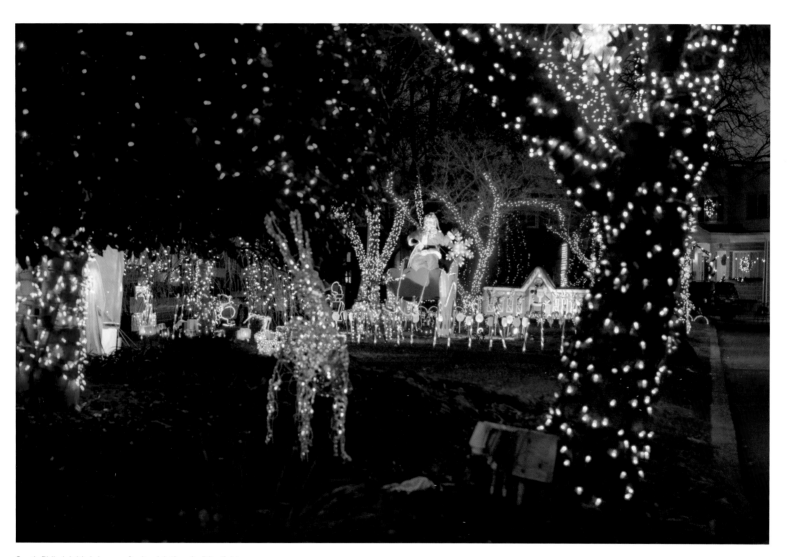

South Philadelphia is known for its nighttime holiday lights.

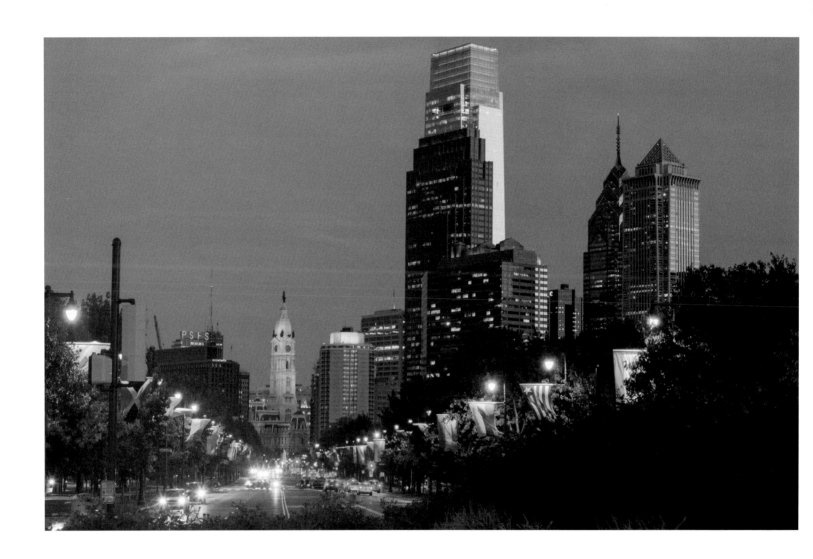

About the Author

Antelo Devereux, Jr., has been photographing since the age of ten. He is a graduate of Harvard College with a degree in architecture from the University of Pennsylvania. He has exhibited his work in Pennsylvania, Delaware, and Maine, and his photographs are held in many private collections. This is his sixth book of photographs of places. Other books include: *Maine Coast Perspectives, Chester County Perspectives, Eastern Shore Perspectives, Maine: Out and About,* and *Chester County: Out and About.* He resides with his family in Chester County, Pennsylvania.

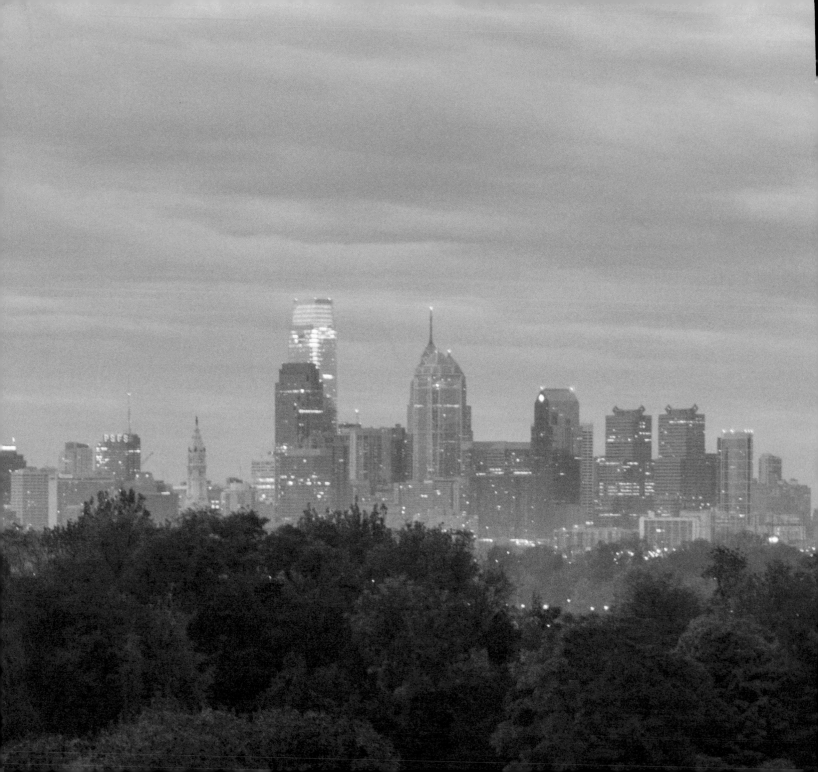